IMAGES
of America

THE ST. GEORGE
PENINSULA

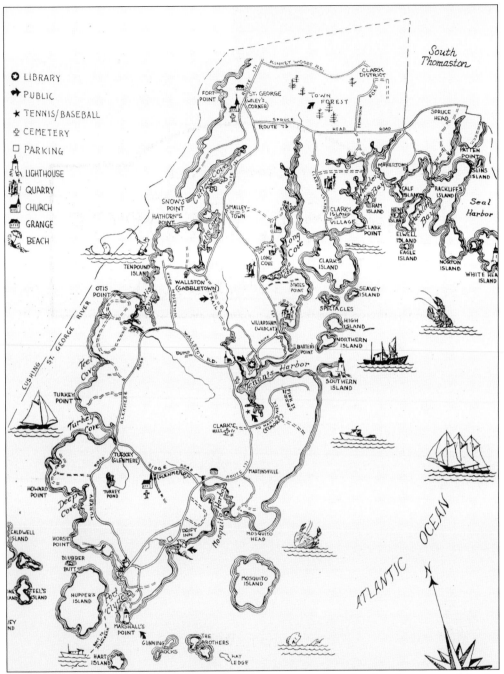

This is a map of the St. George Peninsula. This map was used inside a brochure created for the library in the 1960s. The brochure was reprinted again in 1984. (Courtesy of Jackson Memorial Library, artwork by Janice Tate.)

IMAGES
of America

THE ST. GEORGE
PENINSULA

Tammy L. Willey

Published by Arcadia Publishing
Charleston SC, Chicago IL, Portsmouth NH, San Francisco CA

Printed in Great Britain

Library of Congress Catalog Card Number: 2005923834

For all general information contact Arcadia Publishing at:
Telephone 843-853-2070
Fax 843-853-0044
E-mail sales@arcadiapublishing.com
For customer service and orders:
Toll-Free 1-888-313-2665

Visit us on the Internet at http://www.arcadiapublishing.com

On the cover: This tranquil image of Tenants Harbor was taken in the early 1900s. To the right is the schooner, *M. K. Rawley*, which weighed 302 tons. The Bean and Long Company built her in 1874. In the dory, to the left is Ezekiel Holbrook.

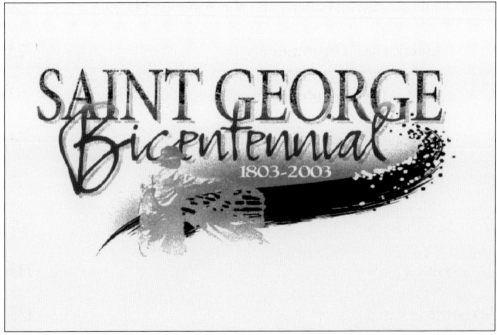

This interesting logo, designed by local graphic artist Doug Anderson, was used as a representation of the St. George Bicentennial in 2003. The town held many special events to celebrate the 200th anniversary of St. George breaking away from Cushing, Maine, in 1803 and becoming its own township.

CONTENTS

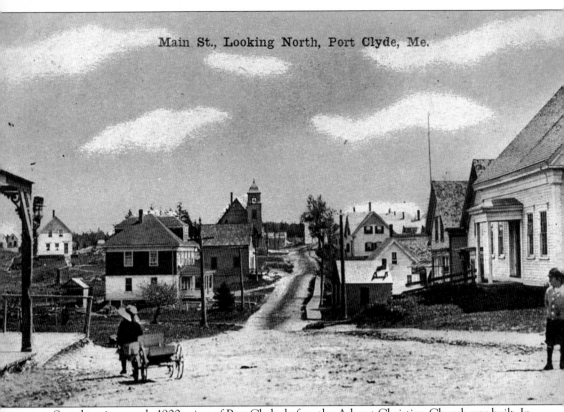

Seen here is an early 1900s view of Port Clyde, before the Advent Christian Church was built. In the background, you can see the Port Clyde Baptist Church, built in 1897. The small child to the right is standing in front of the Ocean House (not visible). The Ocean House is still in operation.

INTRODUCTION

To find St. George on a map of Maine, locate the long peninsula—1 to 2 miles across and about 12 miles top to bottom—that forms the southwest boundary of Penobscot Bay and points seaward toward Monhegan Island. Flying over the peninsula, one is struck by the fact that its center is covered by spruce and mixed forest. The homes of most of the 2,500 inhabitants are clustered in villages around the coves and harbors and strung along the road that follows the shoreline.

The larger villages are St. George, Long Cove, Tenants Harbor, Martinsville, Port Clyde, Clark's Island, and part of Spruce Head. There are several more hamlets or areas. If asked where they live, most people from St. George provide the name of their village rather than the town. Even the state television weather reports give conditions for Port Clyde or Tenants Harbor rather than for St. George. As a result, the name of St. George is not recognized as readily as others.

But St. George is nonetheless one of the oldest English place names in America, predating Jamestown and Plymouth. George Waymouth, an English explorer, visited the area in 1605. He took note of the natural resources—fish, furs, and timber—and even planted an experimental garden to see if English seeds would grow in the New World. His published report led to the formation of the London and Plymouth Companies. Since the time of Waymouth—who gave the name in honor of England's patron saint—the area and river have been called St. George or St. Georges, and when the town was incorporated in 1803, it chose to retain the ancient name of St. George.

There might have been temporary trading posts or fishing stations here in the 1600s, but no permanent settlement was made until after the end of the French and Indian Wars in 1763. Settlements had been established upriver in Warren in 1736, and across the river in Cushing in 1743, but an agreement between Massachusetts land developers (patentees, or proprietors, as they were called then) and the American Indians forbade settlement on the east side of the river. The defeat of the French and their American Indian allies in 1763 left the natives powerless to enforce the agreement, and a trickle of settlers ventured into St. George in the 1760s.

At the time of the American Revolution, fewer than 20 homes stood in St. George, but at the close of the war, a flood of settlers (many of them veterans) began to arrive. Apparently they believed that the revolution had rendered void the claims of absentee landowners based on an ancient English patent.

These settlers quickly "took up" the hundred-acre lots that had been marked off by the proprietors for future sale. Later, the government declared the ancient patent valid, and Henry Knox came into ownership of most of the patent lands through his wife, Lucy's, descent from the

chief proprietor, Samuel Waldo. Settlers had to pay the Knoxs for the land they had cleared. Most of the people who settled on the riverside of the peninsula were children and grandchildren of the Scotch-Irish who had earlier settled in Warren and Cushing. Settlers on the Penobscot Bay side were generally of English descent, from Massachusetts and other towns to the westward, particularly Harpswell, Boothbay, and Bristol.

These first settlers eked out a living by cutting wood and hauling it to landings along the shore, where they exchanged it for food and necessities brought from Boston in vessels called coasters. As the forest receded and cattle kept down new growth, land was cleared and fences and walls were built. Well into the 1800s, log houses were the typical dwellings. The oldest house in St. George is the one built for Capt. Samuel Watts before 1775. Framed with timbers and covered with planks rather than boards, the home remains in excellent condition. British marauders entered the house during the Revolution and took Watts to Castine, where he was held captive for several weeks.

By the early 1800s, some shipbuilding had begun, and the majority of the men were employed, at least part-time, in fishing or aboard coasting vessels, enabling the town's population to reach a density that could not have been sustained by agriculture alone.

Granite quarries were opened in the 1830s, most often owned by individuals or corporations from away. By the late 1800s, hundreds of men were employed in cutting street paving or building stone at the major quarries at Spruce Head, Clark's Island, Long Cove, and Wildcat. Many, if not most, of the earlier granite workers were from England, Ireland, Wales, and Scotland. But as shipping declined, more local men were employed in the quarries, or as stone or paving cutters. After 1890, Finnish people arrived, and by 1910, large numbers of Scandinavians. The granite business declined after the 1920s and came to an end in the 1960s. Over time, most of the immigrant workers and their families moved away, but enough married into the local population and remained to give St. George a more diverse and perhaps a more cosmopolitan population than most Maine coastal towns.

Shipbuilding boomed in the 1850s, making Port Clyde and Tenants Harbor thriving villages. Lobsters were shipped from St. George, particularly from Port Clyde, to New York as early as 1855. Fish processing continued at Port Clyde until the sardine factory burned in 1970. Today, St. George is one of the state's most important lobstering towns, and Port Clyde is second to Portland in ground fishing.

The First Baptist Church of St. George, organized in 1789, is the oldest religious society in Knox County and is the parent church of the Baptist churches in Martinsville, Tenants Harbor, and Port Clyde. An Episcopal chapel was built at Long Cove in 1901 to provide for the spiritual needs of the village's English and Scottish granite workers. The chapel is still used during the summer months. An Advent congregation is active at Port Clyde and meets in an attractive building designed by Arctic explorer Russell Porter in 1916.

The Keeper's House at Marshall Point Light has been restored and is maintained as a museum by the Marshall Point Lighthouse Committee of the St. George Historical Society. More than 12,000 visitors enjoy the museum and its grounds annually. Also of historic interest are the remains of Fort St. George, located in the northern part of town on the shore of the St. George River. Built by the federal government in 1809 to protect shipping along the river, the fort was captured by the British in 1814. Now the earthworks and cellars of the barracks, blockhouse, and powder house remain as the only identifiable fort site in Knox County.

The population of the town declined drastically from the 1880s to the 1950s, but since the 1960s, St. George has experienced an ever-accelerating growth. Happily, the people in this present wave of settlers are well educated, many of them retirees, who have been drawn here because they appreciate the town's scenic beauty and relative tranquility. They are, for the most part, more than willing to participate in community activities and to assume a share of responsibility for keeping St. George a pleasant place to live.

—James Skoglund

One

Memorial Day, Soldiers, and the American Legion

ADVERTISE IN TOWN TALK!

If you want to swap horses,
If you want to trade carriages,
If you want to hire help,
If you want a situation,
If you want to sell goods,
If you have lost anything,
If you have found anything,
If you want to hire a tenement,
If you want to let a tenement,

ADVERTISE IN TOWN TALK!

Town Talk, the local newspaper, was published for approximately six years in the late 1800s. If one wanted to buy or sell an item, an ad in the Town Talk was an effective tool.

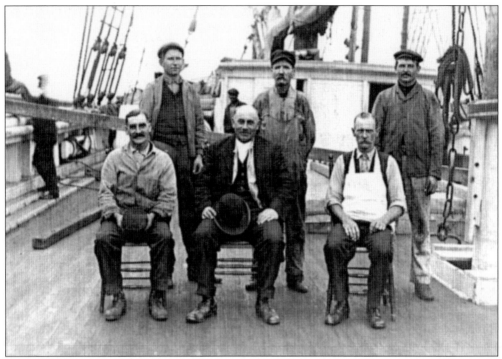

Capt. Charles E. Holbrook (first row, center) appears with crew members aboard the *Hattie Dunn* in Savannah, Georgia, in 1915. A resident of Tenants Harbor, he mastered the 435-ton vessel until it became the first American ship captured and sunk by a German submarine along the eastern seaboard during World War I. The captain, who first went to sea at 14 years old, spent eight days as a prisoner of war aboard the submarine, reportedly befriending many of the German officers and reuniting with childhood friends.

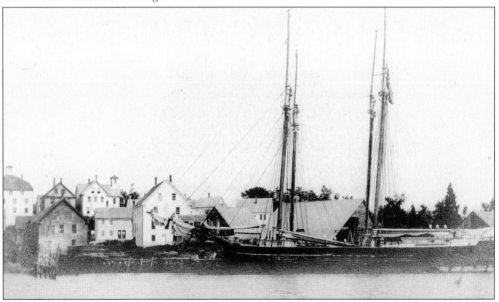

The *Irene Meservey*, built in Waldoboro in 1866, was one of the last schooners docked at St. George. Charles E. Holbrook served as captain.

Charles Gillmore of Port Clyde captained the *Edna*, a 325-ton schooner, during World War I. En route to Santiago from Philadelphia and holding 10,000 cases of gas and oil, the ship was shelled and captured by the same German submarine carrying the *Hattie Dunn*'s captain and crew. The *Edna*'s shipmates, who were African American with the exception of the captain and one Portuguese sailor, were transferred to the U-151 and the vessel was destroyed. Once childhood friends, Captains Gillmore and Holbrook had not met in 30 years until they became POWs together.

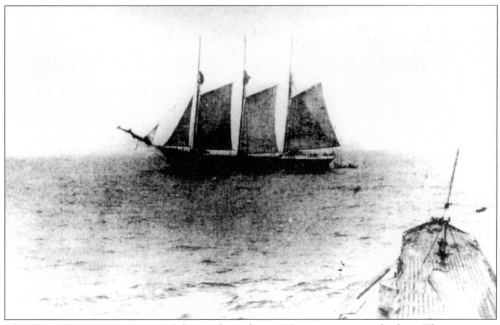

The *Hattie Dunn*, measuring 145 feet and weighing 435 gross tons, was built in Thomaston in 1884. This ship was the first American vessel downed by a German submarine off the East Coast during World War I. This photograph was taken aboard the German submarine that sank her on May 25, 1918. (Courtesy of Elwood Brown.)

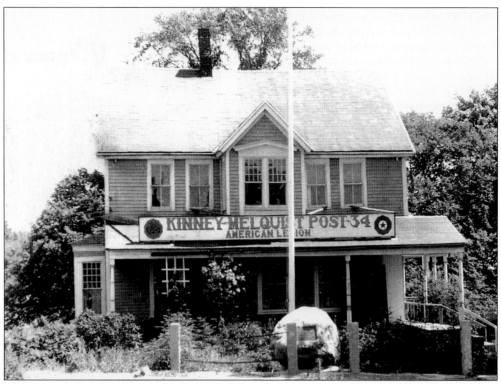

The original American Legion Hall was the sight of many town celebrations. The War Memorial in front of the hall was moved to its current location when the new hall was built. The Legion hosts the yearly Memorial Day festivities and parade.

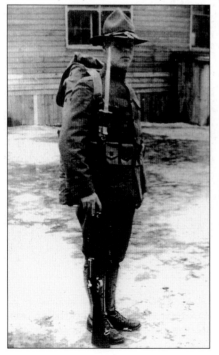

Pvt. Austin R. Kinney was killed in action at Chateau-Thierry on July 18, 1918. He enlisted on September 20, 1917, and served with Company D, 9th Infantry, earning a Purple Heart. The Kinney-Melquist American Legion Hall Post 34, located in the village of Tenants Harbor, was named in his honor.

John Henry Melquist, who is also honored by the American Legion's name, was killed in action in Gurzinch, Germany, on December 24, 1944. Enlisting on March 6, 1943, he served with the 104th Infantry. He was awarded a Purple Heart, Bronze Star, and a Unit Citation from the British Government for outstanding service.

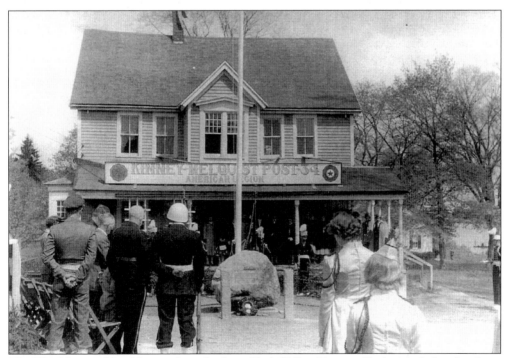

The War Memorial boulder was brought from Clark Hill in Tenants Harbor and placed in front of the first American Legion Hall in 1950. A bronze tablet mounted in the front of the stone honors war hero John Henry Melquist.

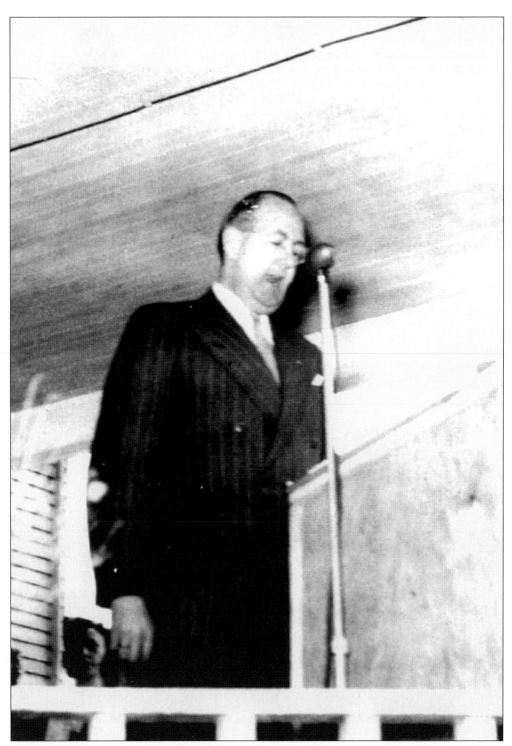

Gov. Frederick G. Payne was the honored guest speaker at the American Legion's Memorial Day observance in Tenants Harbor on May 30, 1950. Maine governor from 1949 to 1952, he and his wife lived in the Blaine House in Augusta with their Chinook dog Dirigo.

John A. MacNeil wears a Canadian military uniform. Kinney-Melquist American Legion Post No. 34 was "born" in his barn at the head of the harbor on August 20, 1946, when temporary officers were named. The first meeting was held at the Grace Institute on September 11, 1946, when permanent officers were elected. Installation was on October 16, 1946. Hector Staples of Rockland, past state commander, was the installing officer.

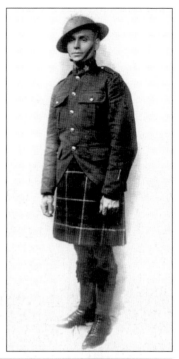

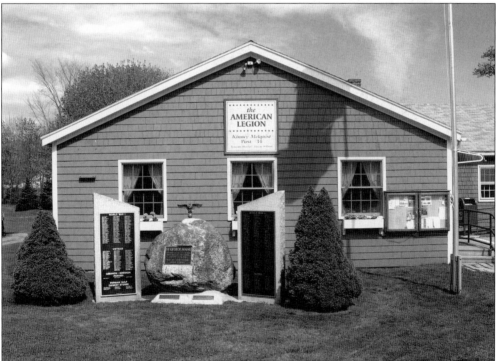

The new American Legion Hall, located in Tenants Harbor, was expanded in 1996. The original meeting area was a small room off the side of the post office. The Veterans Memorial stands in front of the Legion Hall. The boulder has been expanded to include large pieces of granite on each side, with names of veterans carved into mounted brass plates. (Courtesy of Abby Hickey.)

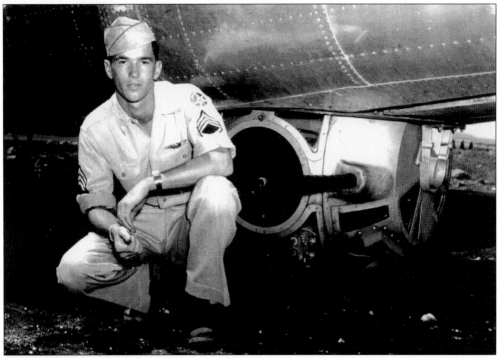

Malcolm Wiley served in the U.S. Air Force as an assistant radio operator and ball turret gunner during World War II. A member of the 30th Heavy Bombardment Group, 819th Heavy Bombardment Squadron, 7th Air Force, he is pictured here in Saipan, Mariana Islands, on December 19, 1943.

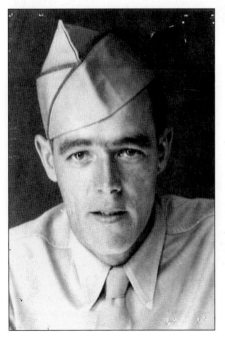

This handsome photograph of soldier Arnold Stanley was taken in 1943, when he was 26. He enlisted in the army with four of his brothers: Norman, who was in Europe; Vernon "Bun," who was in the Pacific; and Carlton and Clyde, who worked on a supply ship. Arnold worked in maintenance, ensuring that the guns were in order.

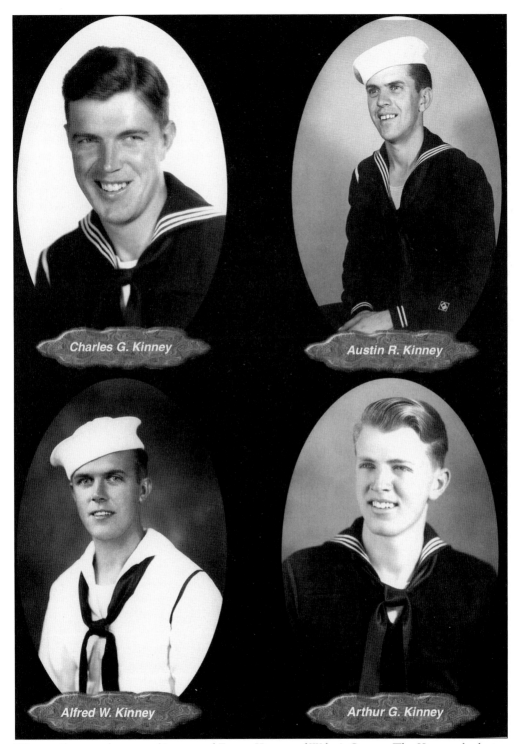

Charles G. Kinney

Austin R. Kinney

Alfred W. Kinney

Arthur G. Kinney

These sailors are the sons of James and Emma Kinney of Wiley's Corner. The Kinneys had nine children, as large families were common in the "old days." Charles, Austin, Alfred, and Arthur Kinney served in the navy during World War II.

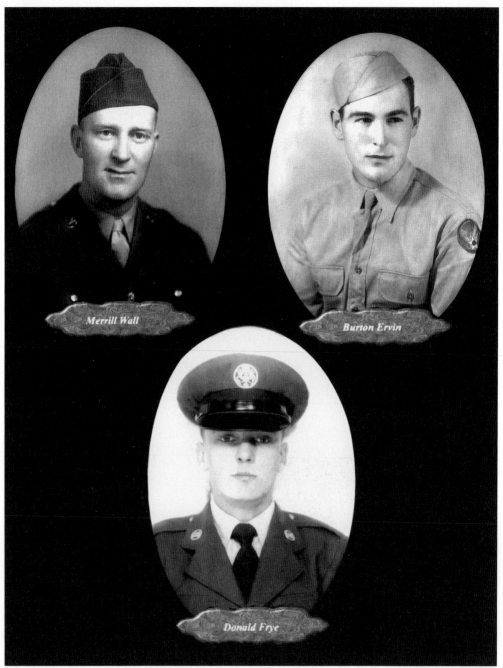

The soldiers in these photographs are James and Emma Kinney's sons-in-law who were in the military during World War II. One served in the U.S. Army, and another in the Army Air Corps. A third served during the Korean War.

Members of Kinney-Melquist American Legion Post No. 34 perform Memorial Day exercises on May 30, 1948. Marching up Main Street in Tenants Harbor, from left to right, are Norman Martin (World War II), Cecil Polky (World War II), Don Wood (World War II), Charles Wall (World War II), and Arthur Ingersoll (World War I) in the front.

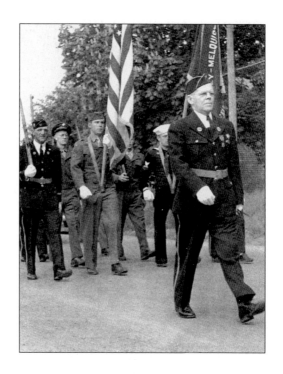

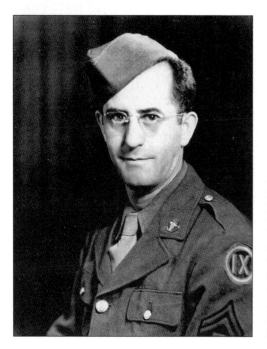

Emerson Murphy, a native of Tenants Harbor, lived from June 25, 1908, to March 25, 1978. Officer Murphy was a member of the 7th Armored Division of the 3rd U.S. Army. During World War II, he fought with other American soldiers for the liberation of France. A plaque located in the village of Ville-sur-Yrou, France, honors Murphy. A close friend sent a duplicate plaque from France, and this was placed on his grave at Seaside Cemetery.

Sylvanus Robinson, the son of Capt. James and Catherine Clark Robinson, wears his Civil War uniform in this image. Sylvanus was raised in the home now owned by Sally Jo Kinney. His great-grandson, Chief Tim Polky, recently celebrated his 25th year with the St. George Fire Department.

Donald Wood worked as a torpedo man 2nd class on the USS *Philip*, DD (Destroyer) 498. A navy veteran of World War II, Wood was a charter member and past commander of Kinney-Melquist American Legion Post No. 34. He was awarded nine battle stars, representing the nine major naval engagements in which he was involved.

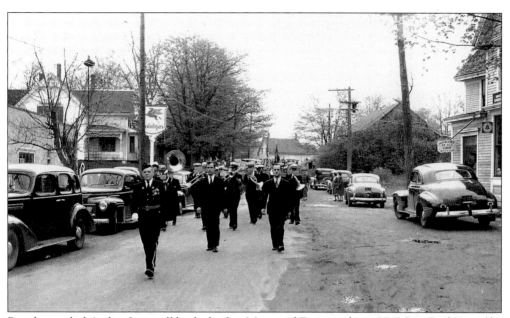

Parade marshal Arthur Ingersoll leads the first Memorial Day parade, in 1947. Rev. Earl Hunt (far right) was the featured speaker at high school ceremonies. The Rockland City Band follows.

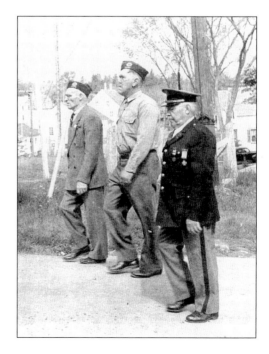

Like others across the country, St. George veterans gather each year to honor those who did not make it home. Marching uphill to St. George High School during the town's first Memorial Day ceremony in 1947 are (from left to right) John MacNeil (World War I), Orel Gehrmann (World War II), and Alec Humphrey (Spanish-American War).

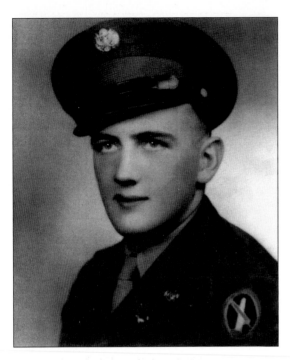

Donald W. Wilson Jr. was born on May 14, 1930, and was killed in action on September 12, 1950, in Korea. He served with the U.S. Army, 2nd Infantry, 23rd Regiment, K Company.

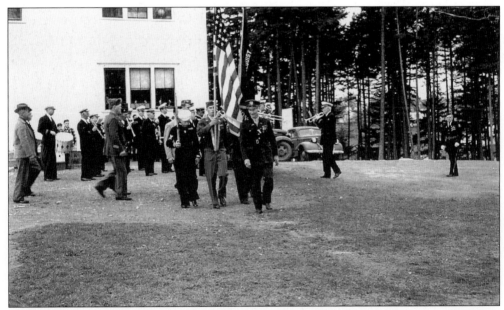

World War I veteran Ralph Cline leads the color guard during Memorial Day ceremonies at the high school grounds in 1947. The school no longer stands, but Sergeant Cline remained a distinguished and familiar figure in the annual ceremonies until his death. His image was immortalized in Andrew Wyeth's portrait *The Patriot*.

Vernon "Bun" Stanley enlisted in the army in 1943, joining four of his brothers, and was sent to the South Pacific. He remembers being on the beach at Leyte Island the very day Gen. Douglas MacArthur and his entourage landed. General MacArthur was heard saying those famous words, "I have returned." (Courtesy of Vernon Stanley.)

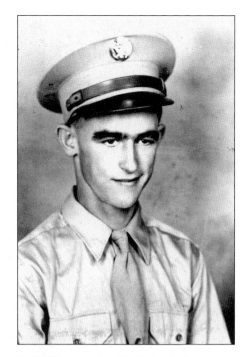

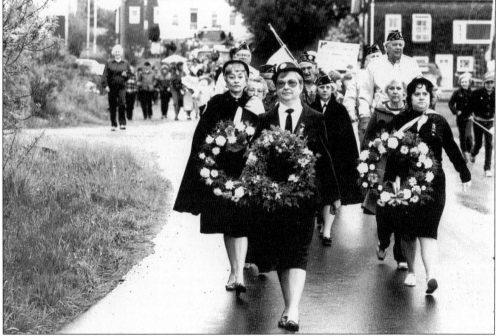

This image shows the 1985 Memorial Day parade at Tenants Harbor. Three Auxiliary members carry the memorial wreaths to the town landing, where they are tossed into the ocean in memory of the St. George residents who gave the ultimate sacrifice for their town and country. Pictured are Joan McKay (left), Joan Anderson (center), and Joyce Wall. The parade is a yearly event in St. George, along with the morning pancake breakfast at the Masonic hall and a special program at the American Legion Hall. (Courtesy of the *Courier Gazette*.)

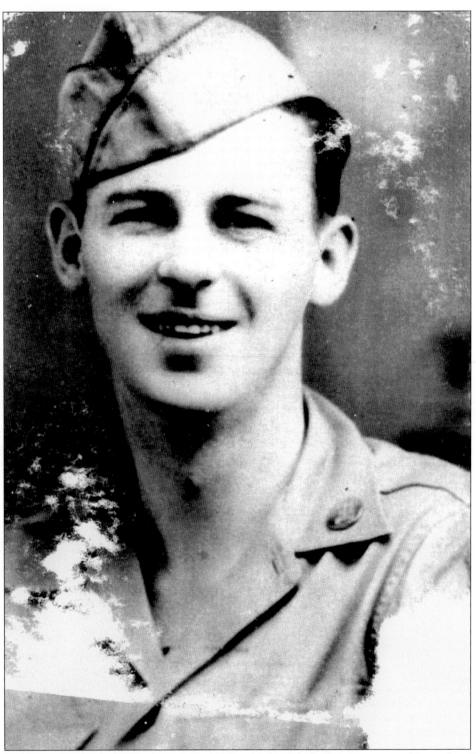

Donald R. Johnson, born on August 18, 1928, gave his life for his country on November 18, 1950, in Korea. He was in the U.S. Army, 9th Infantry, H Company.

Two

CHURCHES AND
ORGANIZATIONS

"BOOMERANG IS HERE"

FRI. and SAT., JULY 29-30
ODD FELLOW'S HALL,
TENANT'S HARBOR, ME.
AT 8 P. M. Children's matinee
on Sat., July 30 at 2 P. M.

Free Ice Cream to all children
attending. Tickets for the even-
ing performance are 40 cents.
There will be free dancing both
nights after the show. Children
under 15 admitted for 20 cents
at evening performance. All
children must be accompanied
by an adult or cannot be admitted
to the theatre. "Boomerang" is
under the direction of Miss
Carol Mathers, of St. Louis, and
is produced by the Amateur
Theatre Guild, of Boston and
Lakewood, Maine.

The Boomerang was a play performed for only two nights at the Odd Fellows Hall. Free ice cream was served, insuring a sell-out crowd.

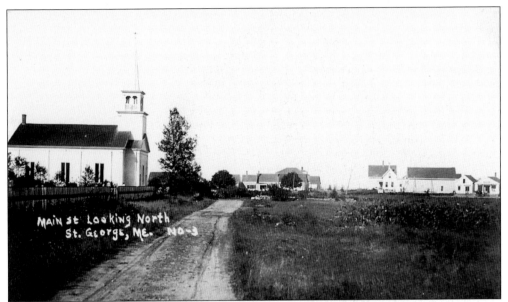

Looking north at Wiley's Corner, this view shows the 1784 First Baptist Church on the left. The St. George Grange roof, also on the left, is visible as the tallest building in this area. The school was located next to the grange.

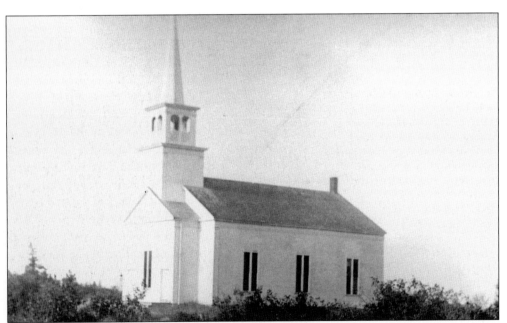

At the instigation of Elder Isaac Case, a missionary from Massachusetts, local citizens built the First Baptist Church in 1839 from a design by Samuel Melcher of Brunswick (1775–1862). The original spire was struck by lightning in 1917 and later rebuilt.

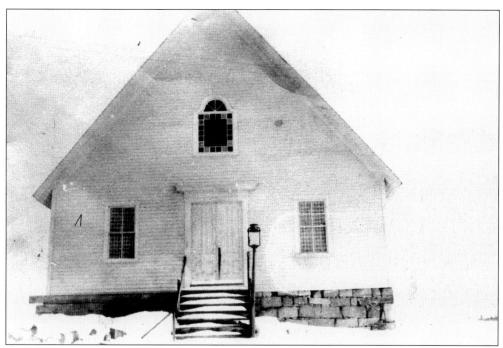

The earliest discussions about building a Clark Island church occurred in 1895. The Clark Island Baptist Church was then built in 1904 on land sold or donated to the parish committee by Clara Douglas.

St. George Episcopal Church in Long Cove, a mile and a half north of Tenants Harbor, was built in 1901 by Albert Rawley to serve the quarry workers' families, most of whom were of Scottish or English background. Until 1962, it served as a mission under churches in Rockland and Thomaston, later assuming a new role as a summer chapel after the closure of the quarry. Opened each summer for 10 or 11 Sundays, it is headed by a vestry of summer and year-round residents from the area and welcomes congregants of various Protestant faiths. (Photograph by Jack H. Neeson.)

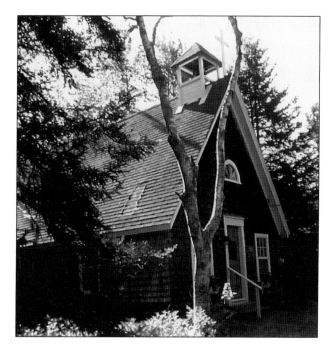

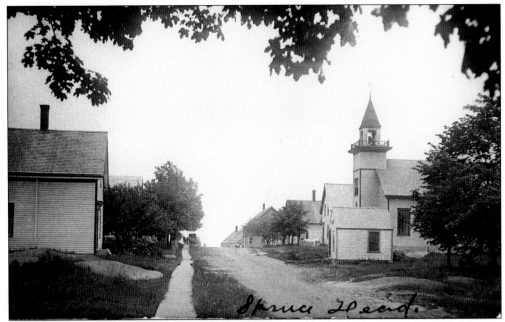

The Spruce Head Church on Village Road was built over a period of several years in the late 19th century. Before that, prayer services were held at the local dance hall (now known as the Community Hall) across the street. The church's first ministers were Elder Bickmore (a Methodist) and Elder Hill (a Baptist). The small adjacent building was a barbershop.

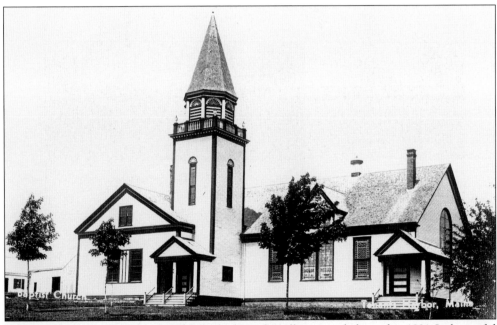

The Tenants Harbor Baptist Church, overlooking the village, was dedicated in 1891. Its beautiful stained-glass windows were gifts; three are memorials. Counting the chapel, the church can seat 550 comfortably.

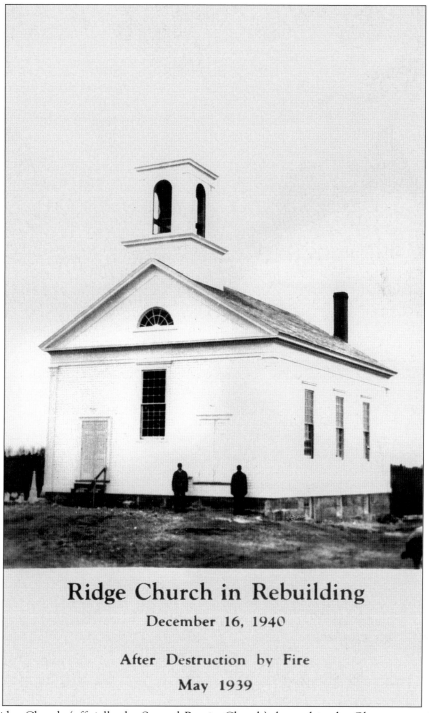

Ridge Church in Rebuilding

December 16, 1940

After Destruction by Fire

May 1939

The Ridge Church (officially the Second Baptist Church), located in the Glenmere section of Tenants Harbor, crowns the ridge between Glenmere (formerly known as Turkey) and Martinsville. Established in 1816, it is still an active congregation, with services, fairs, and other events.

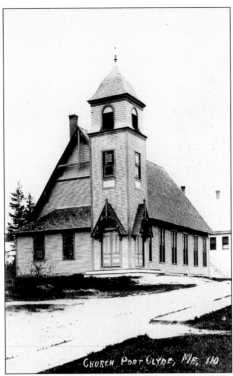

The Port Clyde Baptist Church was built in 1897 to suit the needs of people in the village. Many residents attended the Ridge Church at Martinsville (Second Baptist Church) but found the distance inconvenient. The roads were bad, and not all were blessed with their own horse and carriage. Members who attended the Baptist church regularly and gave money were called the Chapel Society.

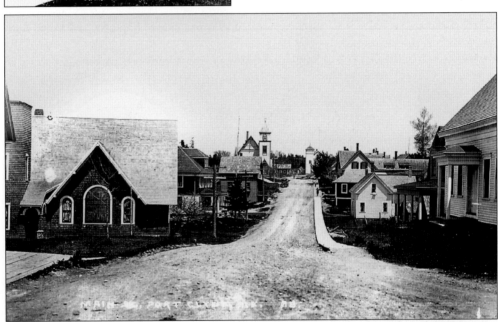

The Advent Christian Church was organized in July 1893, but its church was not built until 1916. Today, the church boasts 50 members and holds services and school on Sundays, a Prayer Meeting on Wednesday evenings, and other services for special Christian festivals. Under the pastorship of Larry Anderson, it is one of the main supporters of the annual Easter Morning Sunrise Service, held at Marshall Point Light, with several other churches. A large community breakfast follows the service.

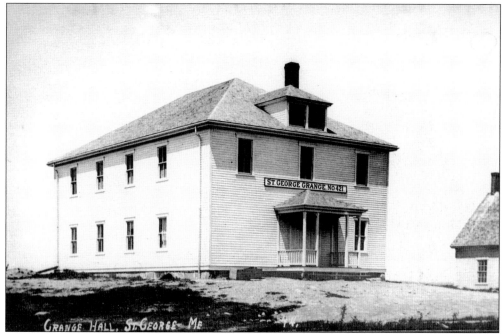

The St. George Grange Hall was built in 1908, after a three-year fund-raising campaign. (The local grange chapter was founded in 1903.) Austin Davis of St. George was the building's contractor, and Edwin Butler of Thomaston was the foreman. The dedication ceremony was held on December 1, 1908. With the exception of a more recent fire escape, the hall has retained its original appearance.

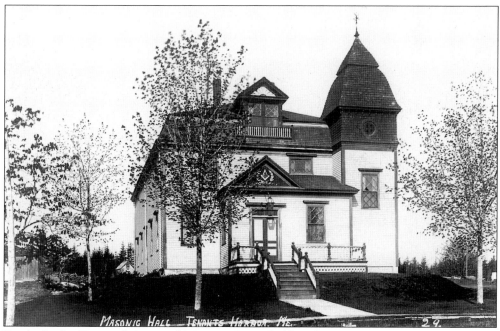

Eureka Lodge Free and Accepted Masons No. 84 held its first meeting on August 6, 1855, at Martinsville. The current Masonic hall in Tenants Harbor was dedicated in 1894.

1923 **1923**

APPRECIATION

M_____

ST. GEORGE LODGE, NO. 132, I. O. O. F., OF ST. GEORGE, ME., BY
VOTE OF ITS MEMBERS, EXTENDS TO YOU AS A MEMBER OF THE
BLACK MOSQUITO MINSTRELS, A VOTE OF THANKS AND APPRECIA-
TION FOR THE SERVICES YOU HAVE SHOWN
IN THE PRESENTATION OF YOUR VALUABLE
GIFT FROM YOUR MINSTREL TO ITS LODGE.

_____NOBLE GRAND

_____SECRETARY

In 1923, the St. George Lodge of Odd Fellows officially thanked the Black Mosquito Minstrels for
its contribution of $300, allowing the cancellation of a $250 mortgage on the group's building.

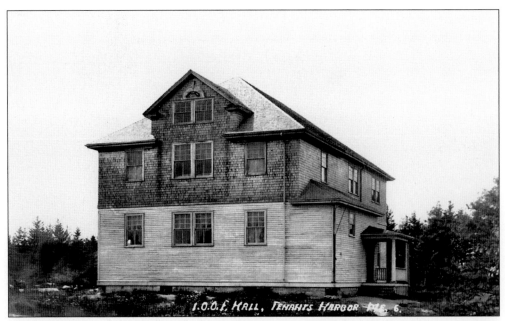

St. George Lodge No. 132 dedicated the Tenants Harbor Odd Fellows Hall on January 20, 1911.
Upon completion of the building, the contractor was paid $4,132.80. Over the years, the hall
has been the site of many town functions, including meetings, public suppers, dances, plays,
concerts, parties, lectures, and high school events. The Odd Fellows and the hall are still active
parts of the community today.

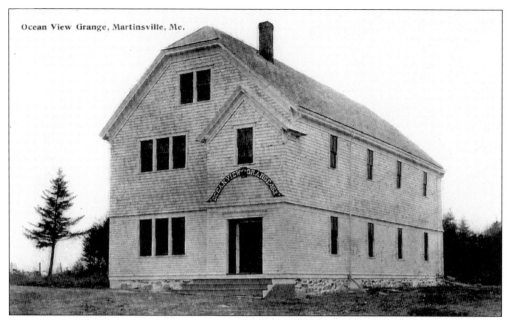

Ocean View Grange, Martinsville, Me.

Ocean View Grange No. 463 is located in Martinsville, a small village of St. George. The Grange was organized on February 19, 1906, and incorporated on July 26, 1906. Though the hall was not completed until 1911, the dedication occurred on November 19, 1906, because members desperately needed a place to gather. The total cost of construction materials, lights, and fire extinguishers had reached $2,512.13 when the hall was finished.

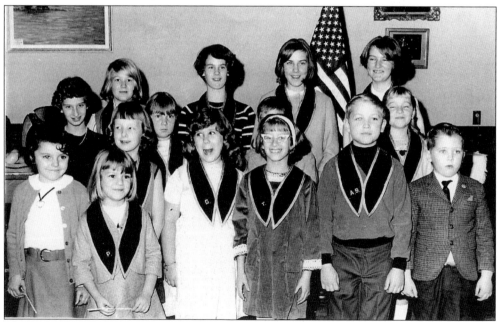

The Ocean View Grange in Martinsville organized the Junior Grange in 1966. Identified here are the following junior members, Marla Reynolds, Katrina Hupper, Theresa Kulju, Janet Korpinen, David Minzy, Thurin Benner, Leslie Korpinen, Betsy Bosquette, Sally Davis, Charles Hupper (hidden), Cynthia Hupper, Gail Bicknell, Terry Minzy, and Janet Hupper.

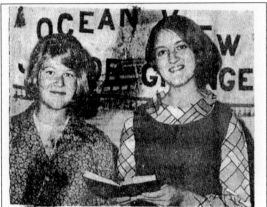

Installation ceremonies for the Ocean View Junior Grange occur in the Grange Hall. Cynthia Hupper, new master, looks over the Junior Grange book held by her sister Janet Hupper, retiring master. The group was organized in Martinsville in the fall of 1966. (Courtesy of the *Courier Gazette*.)

GETTING TO BE A FAMILY THING — Sister followed sister as master of Ocean View Grange and was seated at installation ceremonies held Friday night at the Martinsville Grange Hall. Cynthia Hupper, new master, looks over the junior grange book held by Janet Hupper, retiring master. The youthful grange is beginning its second year, having organized in the fall of 1966. (Link Photo)

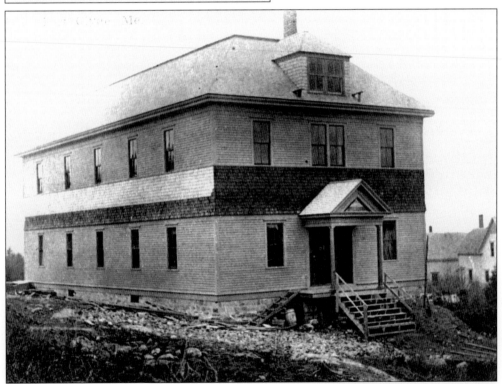

The Knights of Pythias Lodge (Port Clyde Lodge No. 92) was established on May 23, 1894, with 23 charter members. By January 1900, the group included 54 members. At that time, there were 12,000 Knights of Pythias members in Maine; now there are only 800. Some of the members in the early days were Fred Lowell, J. W. Babio, John Bond, Elmer Simmons, W. H. Potter, C. O. Wilkins, Herbert L. Skinner, J. F. Philips, and Z. E. Pease. Dwindling membership eventually forced the lodge to close. The building was renovated in the late 1990s and is now a private residence.

Three

QUARRIES AND GRANITE

Fishing was and still is a very important industry in the villages of St. George, so moorings are needed to hold the boats. Granite moorings are still available.

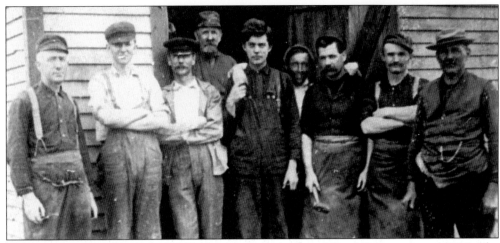

Workers take a break outside the blacksmith shop at Spruce Head Quarry around 1905. The shop was in the same building as, or located near, Allard's Store. The workers, from left to right, are Henry Waldron, Bernard Robinson, an unidentified worker from Whitehead, Tom Keller, ? Wotton, Ed Williamson, Jim Felt, Harvey Kinney, and George Stanton.

NOTICE

Gambling of any kind is strictly forbidden in this building. And we trust that this notice is sufficient, and will be observed, by whom it may concern, so that the management of this Boarding House will not have any unpleasantness trying to enforce the stopping of *Gambling*.

Being absent, kindly give notice to the management of this house, if you are to be away one day or more. Otherwise, you are expected to pay full board.

Cooperation will benefit both the management and those who board here. Try and work together.

JOHN MEEHAN & SON

This stern message was posted in a boardinghouse near the Clark Island Quarry, owned in the 1920s by John Meehan and Son. (Meehan's quarrymen made 52¢ an hour; blacksmiths 75¢.) Boardinghouses, sited close to the quarries, were essential for the granite industry since many of the workers arrived here without their families. The quarrymen came from Scandinavian countries—especially Finland and Sweden—although payroll lists also include Irish and Scottish names, as well as family names dating back to the town's earliest days. Headstones in the cemetery in Tenants Harbor provide ample evidence of the town's multi-cultural heritage. Some boardinghouses were company-owned, while others were privately run. The Craignair Inn at Clark Island was once a boardinghouse, as was the Edwin Tyler House across the street.

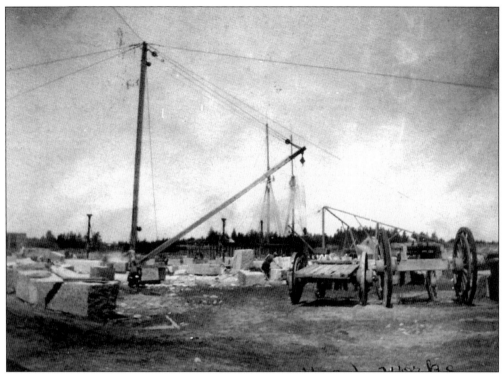

Though this is an image of the Spruce Head Quarry, it is very similar to the John Meehan and Son Clark Island Quarry, which employed over 70 workers in 1924. The hourly rate was between 50¢ and 62.5¢ per hour. The quarrymen "down in the hole" tended to be near the bottom of the wage scale. The blacksmith, an extremely valuable worker, was at the top of the scale.

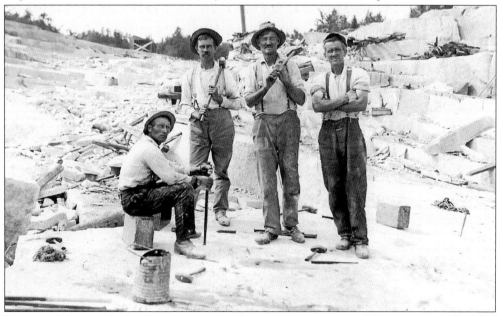

Masters of their craft, St. George quarry workers cut paving stones. These men are identified only by initials. Pictured from left to right are F. W., J. H., F. L., and J. R.

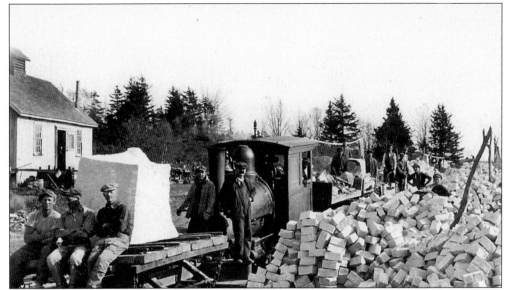

The Wildcat Quarry train was used to move large pieces of granite and paving blocks to a waiting schooner or delivery truck. On the front of the train, from left to right, are Mr. Humphrey, Mr. Anderson, and paving cutter John Berkquist. Inside the train is Rodney Wiley; also pictured on the next train between the platform and train are Leander Wiley and Claude Wiley Sr. (with mustache). The men in the back are unidentified.

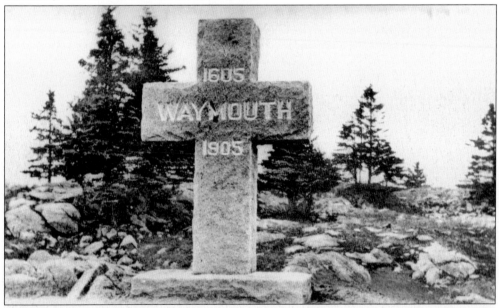

A granite cross on Allen Island serves as a memorial to Englishman George Waymouth, who first explored the St. George River in 1605. His ship *Archangel* anchored off Monhegan Island, which is still known as a rough anchorage. The commemorative cross, carved from local granite, was erected in 1905 as part of the tercentenary of Waymouth's visit. Several events took place on the 2005 anniversary of Waymouth's landing. According to Native Americans today, however, "This is not a time of celebration." When Waymouth left, he took five Native Americans with him, leaving the remaining people with new diseases and illnesses.

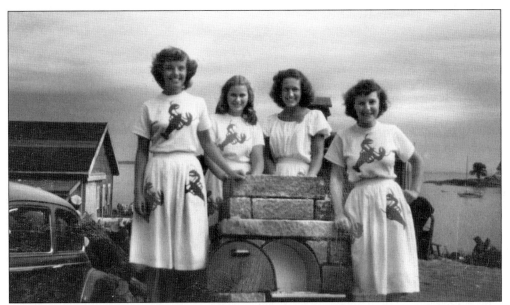

Outdoor granite fireplaces (with or without metal ovens) designed and marketed by Alfred Hocking were popular for many years. Shown here with one of his creations are four "princesses" from the area's annual lobster festival.

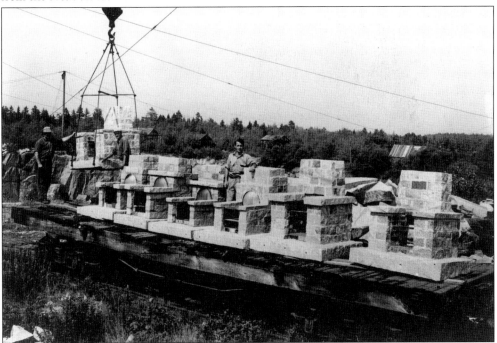

More than a dozen granite fireplaces cover the top of a huge flatbed trailer used to deliver throughout Maine. The trailer was pulled behind a 1937 Buick. Alfred Hocking, owner and manager of the Clark Island Quarry, was the designer of this sideline, which he developed just after World War II. The base of each fireplace measured 52 by 48 inches; the average weight was 3,500 pounds. Master mason John Faustini (center) could make one of these fireplaces in a single day. Also shown in this 1947 photograph are Gus Johnson (left) and John Kulju (far right).

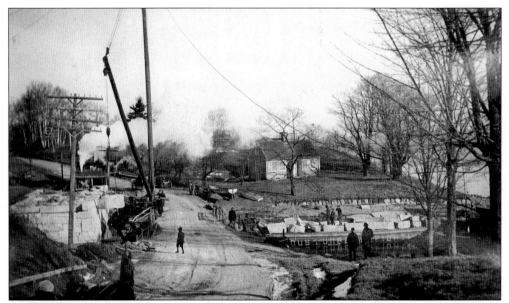

These photographs show the construction of the granite bridge at Little River, on the Northport-Belfast boundary, by workers from the Clark Island Quarry. The project lasted from March 1915 to February 1916.

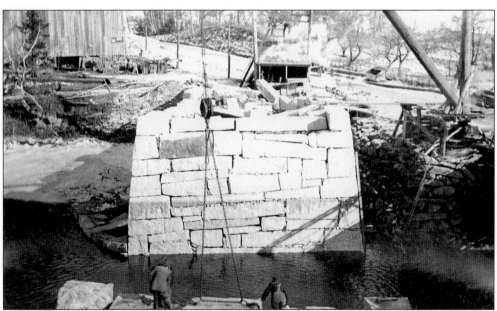

Work on the bridge was completed in less than a year. The crew used a crude crane and pulley system, and did a lot of back-breaking work by hand.

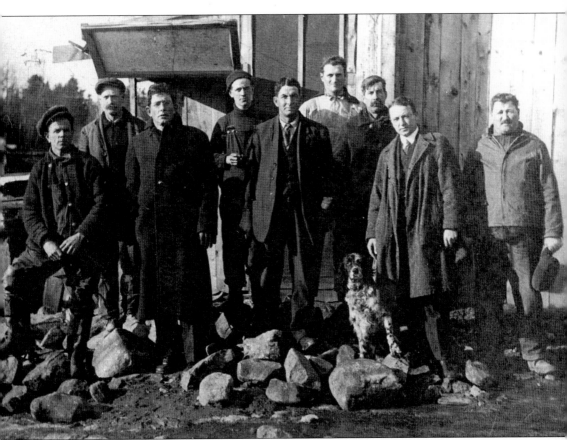

The bridge crew included, from left to right, Rodney Wakefield, Fred Cousins, Capt. John Snow, Austin Huntley, William Hocking, ? Elwell, William Greenlaw, Leland Gilchrest, and A. Moody.

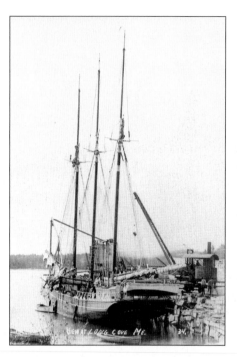

A three-masted schooner, known as a "stone ship," awaits its cargo of granite from the quarry at Long Cove. A schooner carrying the maximum of 35,000 paving blocks was considered "well ladened." A barge would be used for larger shipments of 250,000 blocks. Quarrying began in Long Cove in 1873, when the Smalley family sold land and granite rights to James M. Smith, Joseph Hume, and William Birss.

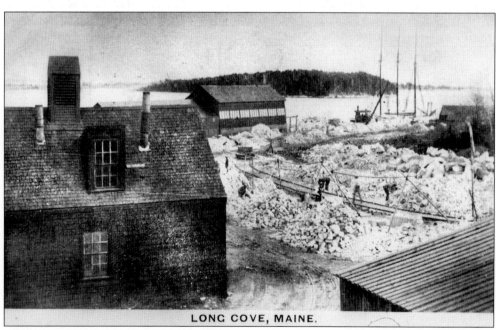

LONG COVE, MAINE.

The last stretch of track winds down to the wharf at Long Cove, where a three-masted schooner waits to be loaded with granite from one of the Davenport steam locomotives used in the quarrying operation.

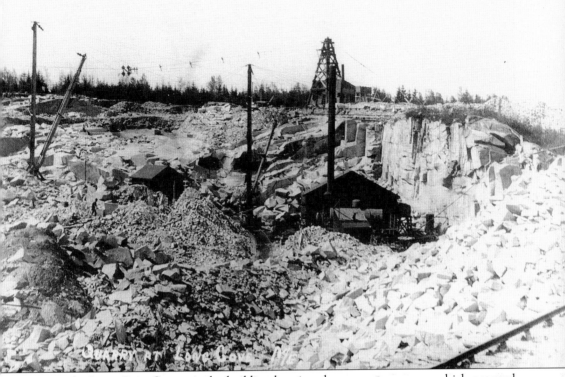

Deep in the Long Cove Quarry is the building housing the steam compressor which powered huge drills and other tools for removing and cutting the granite. Steam was used here until 1922. Note the tracks in the right foreground.

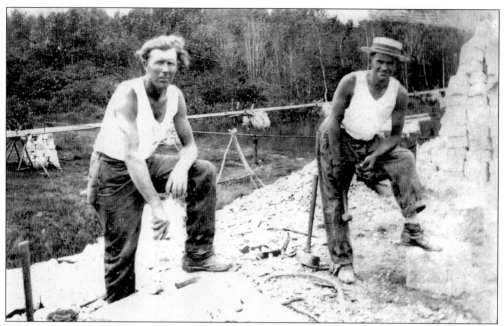

In an era long before OSHA, Oscar Hagberg (left) and Carl Swanson (right) worked at Clark Island Quarry with an astonishing lack of safety gear. Hagberg was later crushed when a large curbstone rolled off a pile and killed him.

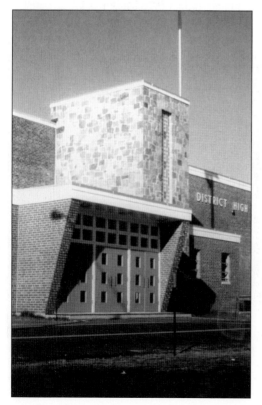

Hocking granite, quarried on Clark Island, adorns the front entrance of the Rockland District High School. The massive stone fireplace at the Samoset Resort in Rockport is also made of Hocking granite, as is curbing used at the United Nations headquarters in New York City.

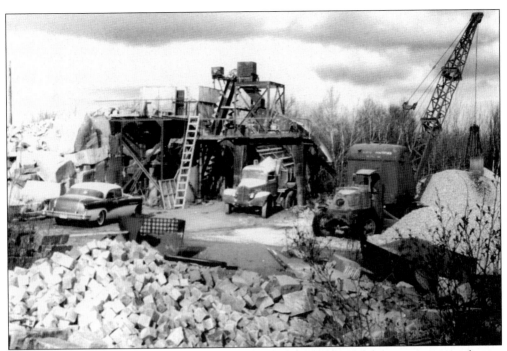

In an early version of recycling, a rock crusher was brought in to this quarry site to pulverize waste granite. The resulting grout was used primarily as fertilizer—providing potassium for gardens. The crane shown in the photograph was mounted on a 1926 Mack truck.

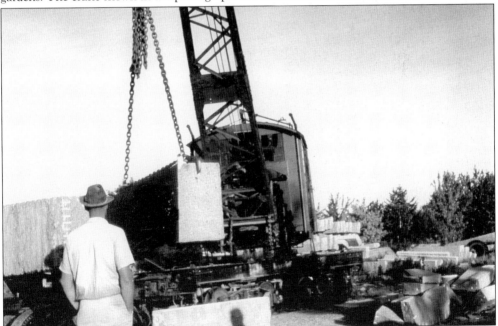

Ozzie Hartison observes activity at the Clark Island Quarry in the 1950s. This railway steam crane—for lifting massive granite blocks—was converted to compressed air, with outlets every 50 feet along the tracks. At one point, five miles of railway track circled the quarry, but most of it had been removed by the time the quarry ceased operations in 1969.

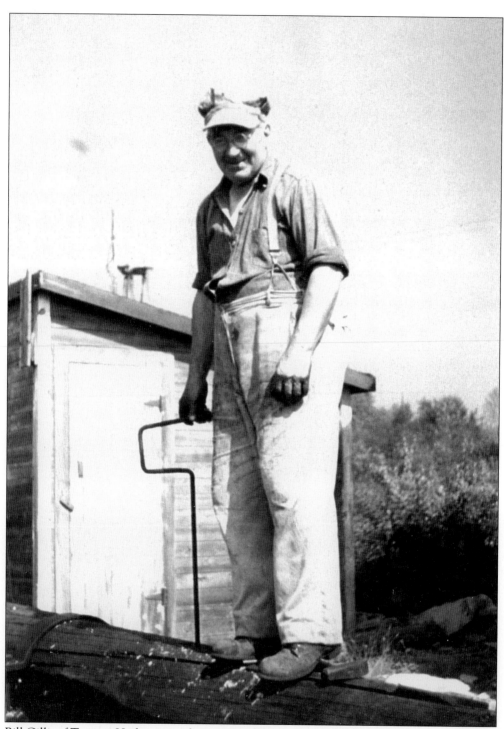

Bill Gillis of Tenants Harbor was a first-rate machinist whose specialized skills were essential in the quarrying business. Here, he hand-drills a hole through an enormous mast so it can be used as a quarry derrick. The mast was bought from Capt. John Snow of Rockland, who salvaged it from a wooden sailing vessel.

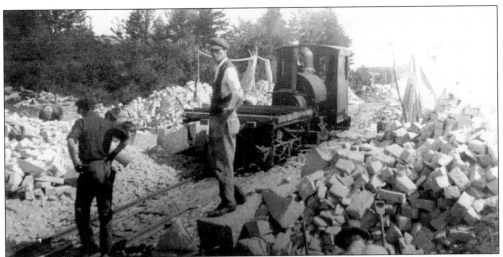

An unidentified worker inspects the steam locomotive track used for transporting granite at the Wildcat Quarry. As recently as 1941, workers at this quarry were unionized, with more than 40 members; less than two years later, only a dozen remained—and they switched their membership to the Clark Island branch. (Hocking Granite on Clark Island was the last of the companies to close down.) Union dues were $1 a month—the local retained 6¢ and the rest went to "headquarters."

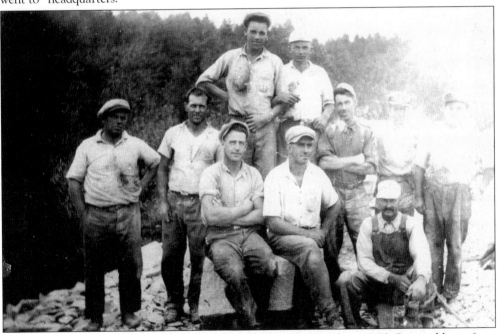

Paving cutters pose for a group portrait at the Wildcat Quarry about 1928. Pictured here, from left to right, are the following: (first row) John Lantz, Gust Lofgren, and Gene Smalley; (second row) Willis Wilson, Oscar Easton, Sixten Johnson, Sven Jacobson, Gilbert Auld, Wesley Mills, and Ed Rawley. The quarry received its unique name from the unpredictability of the granite's grain at this site. Most of the Wildcat stone was cut for paving blocks, and even that was difficult to do without breakage, as evidenced by the massive mountain of discarded granite still looming over Haskell Cove.

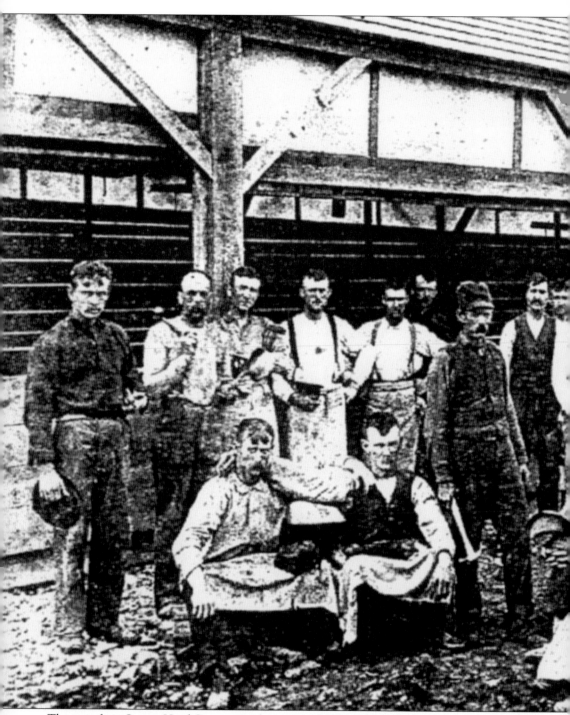

The crew from Spruce Head Quarry pose here around 1900. Although this quarry was outside of town, many St. George men worked there. Though the men in the photograph are not identified, among those posing for the camera are P. S. Alexander, Albert Jones, P. McKnight, Melvin H.

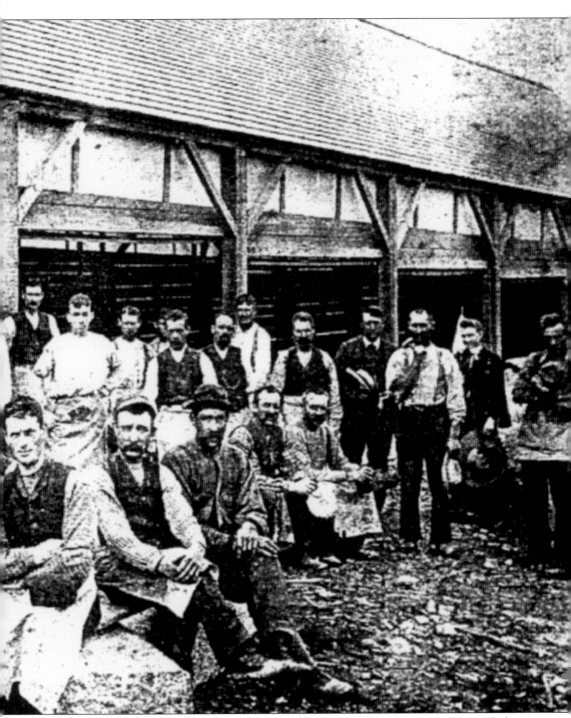

Kinney, James H. Steele, Eben Elwell, P. Philbrick, F. A. Snow, Minnie Burns, and Levi Clark.
Stone from this quarry went to Carnegie Library, the post office in Bar Harbor, Maine, Mutual
Life Insurance Building in New York City, and the columns of the auditorium in Chicago.

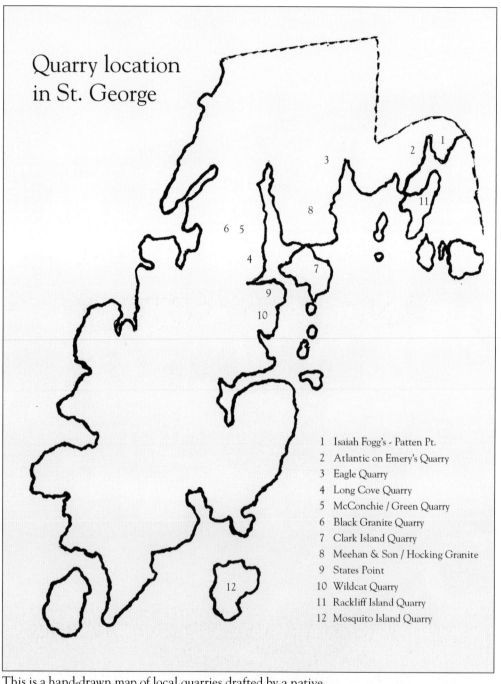

Quarry location in St. George

1 Isaiah Fogg's - Patten Pt.
2 Atlantic on Emery's Quarry
3 Eagle Quarry
4 Long Cove Quarry
5 McConchie / Green Quarry
6 Black Granite Quarry
7 Clark Island Quarry
8 Meehan & Son / Hocking Granite
9 States Point
10 Wildcat Quarry
11 Rackliff Island Quarry
12 Mosquito Island Quarry

This is a hand-drawn map of local quarries drafted by a native.

Four

COMMERCE, FISHING, AND THE FACTORY

W.F. HOLBROOK
SOUTH SIDE
Would inform his old customers that he has now a quantity of
DRIED FISH.

Dried fish, a tasty treat, was more common in the early 1900s. Codfish was cleaned, salted, and laid flat to dry in the sun. South Side was part of Tenants Harbor.

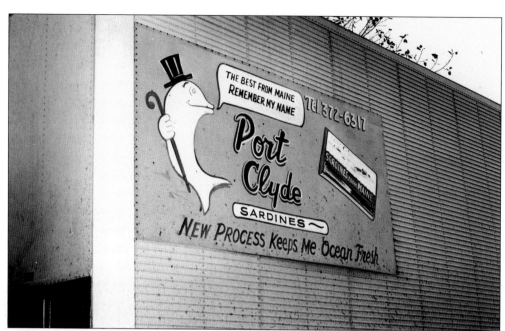

Port Clyde sardines were considered the best because of the size of the fish packed in the cans. The old-timers say, "The sardines were small and very tasty on a saltine cracker." Searching around St. George, one can probably find a can of Port Clyde sardines even today. (Courtesy of the *Courier Gazette*.)

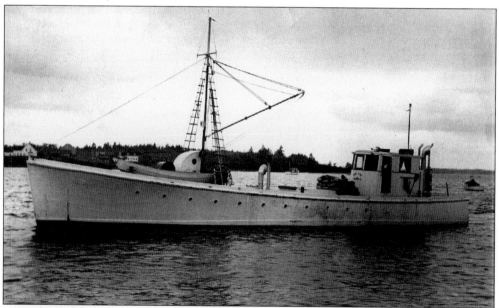

The *Delca*, an 82-foot wooden-hulled vessel, was built in 1936 in Jacksonville, Florida, and served as a military mine sweeper during World War II. Later, the vessel was purchased by the Port Clyde Packing Company and converted into a carrier for sardine fishing. The *Delca* was one of several carriers owned by the company, which brought fish into Port Clyde Harbor for processing. In September 1989, the ship sank in 150 feet of water near Port Clyde. The crew was safely rescued.

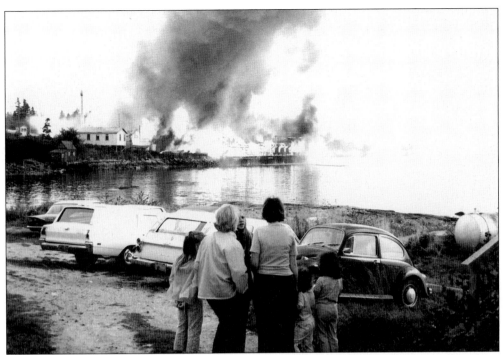

Minutes after the fire alarm sounded on September 26, 1970, the Port Clyde Packing Company, owned by Saul Zwecker, was engulfed in flames, burning to the ground in slightly more than an hour (above). Extreme heat and explosions melted the sardine cans in the old wooden factory building (below). About 200 people lost their jobs, some finding work in Rockland and others transferring to the Royal River Packing Company in Yarmouth, also owned by Zwecker.

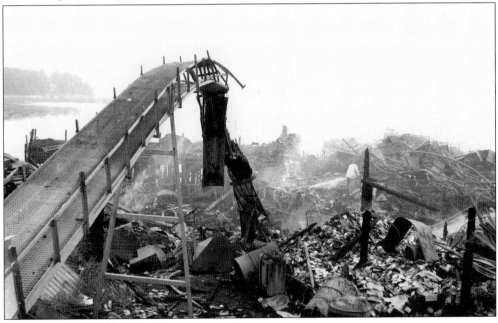

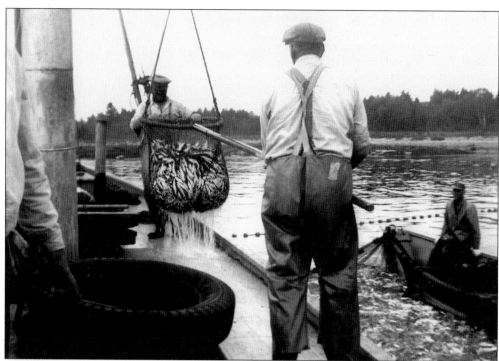

Lobsterman Harry Lowell is fishing in the early 1940s (above). He removes herring from the pocket located between the carrier and a smaller boat. The fish were stored on ice in the carrier and taken to a plant for processing (below). Profits from lobstering in the early days were minimal, and fishing provided an added income for a family.

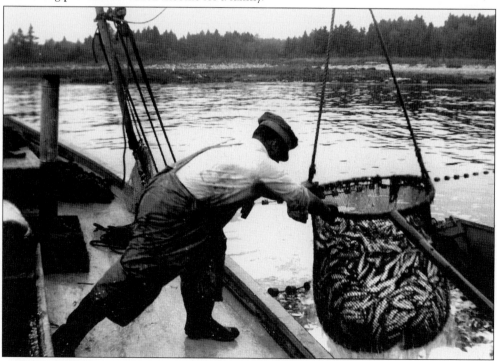

In this early 1940 photograph, local fishermen Harry Lowell (left) and Maurice "Block" Thompson (right) load herring onto a carrier. A large basket is attached to the end of the rope they are holding. The fish would be put into that basket and then placed down inside the "hole" of the carrier.

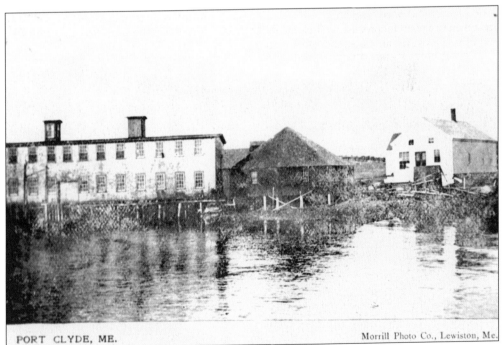

PORT CLYDE, ME. Morrill Photo Co., Lewiston, Me.

The sprawling Burnham and Morrill Clam and Canned Lobster factory was located near the present-day Monhegan Boat Dock in Port Clyde. On the right, the Dewey Thompson house served as a dining room for factory workers (both men and women), who reportedly received 25¢ an hour for their fish-packing labors. Children under 14 were also known to work there.

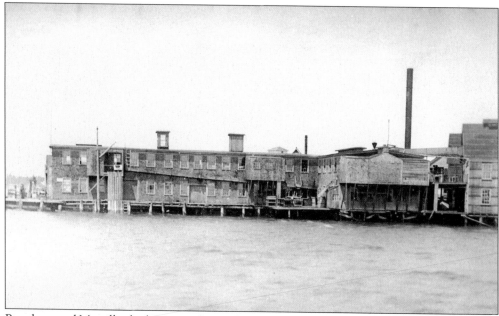

Burnham and Morrill, which occupied considerable Port Clyde shore frontage, ceased its lobster-canning operations around 1900.

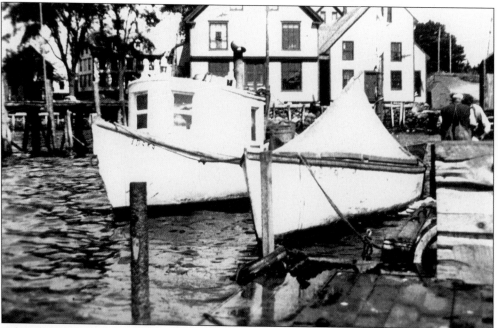

Taken from the dock of the Port Clyde General Store, this early-1930s view shows the working waterfront in Port Clyde. The boat on the right has a canvas wheelhouse; the one on the left boasts one of the then-popular windowed wheelhouses. (Courtesy of Stephen Adams.)

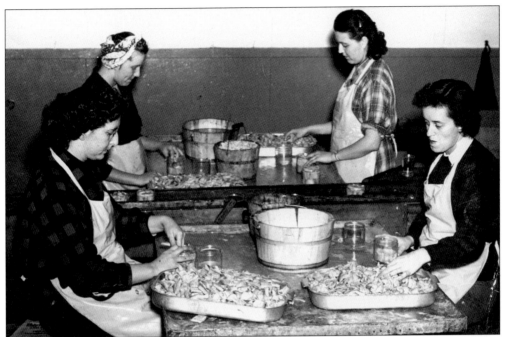

The Port Clyde Packing Company—known for its tinned sardines—was the largest employer in St. George for most of its existence. Among its workers were St. George residents, clockwise from bottom left, Doris Simmons, Catherine Anderson, Verena Andersen, and Vera Powell. Prior to the sardine-canning operation, the company processed pickled herring under the Delta label. (Courtesy of Sid Cullen.)

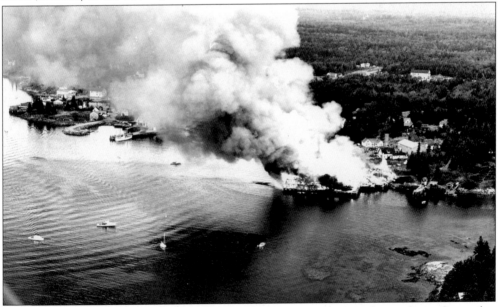

This aerial view gives an idea of the enormity of the Port Clyde Packing factory fire on September 24, 1970. Soon afterward, there was a lot of talk about rebuilding the factory, but in the end it was not rebuilt. The workers went to other factories to work. Today, all that is left of this packing industry are the "fish tales." (Courtesy of the *Courier Gazette*.)

Henry Benner used this wooden sloop to haul his lobster traps off Port Clyde in the late 1800s.

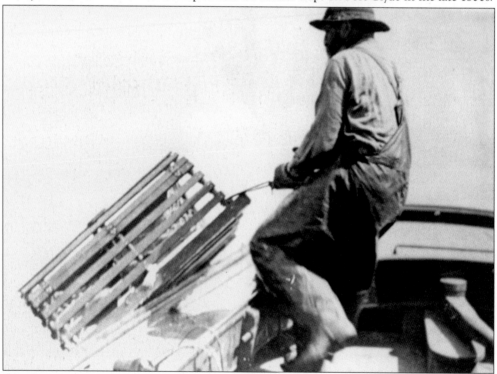

Like everyone else in the late 1800s (and even up to the late 20th century), Henry Benner hauled his heavy wooden lobster traps by hand. Nowadays, even with lighter wire-coated traps and hydraulic gear, lobstermen still put in a hard day's work.

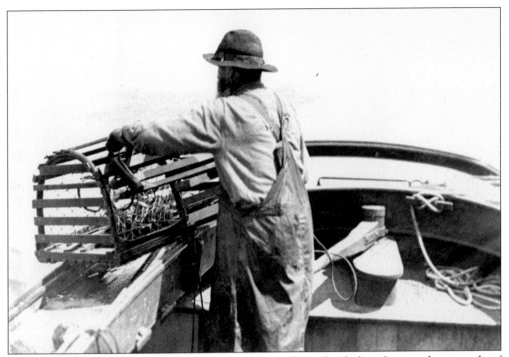

Henry Benner balances a lobster trap—the traditional wooden lath style—on the gunwale of his sloop in the late 1800s.

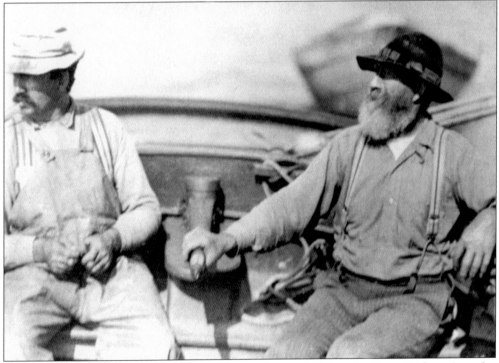

Henry Benner, with his hand on the tiller, and his son head out in Benner's sloop for a day of hauling.

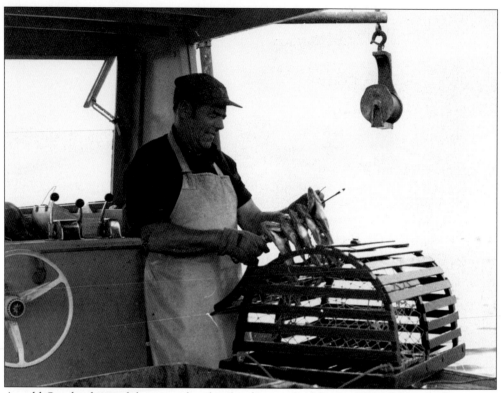

Arnold Stanley began lobstering shortly after he returned home to the Martinsville section of St. George following World War II. Born and raised in Martinsville, he spent 50 years as a lobsterman. His fellow fishermen gave him high marks for his skill at knitting heads, an essential part of traditional traps.

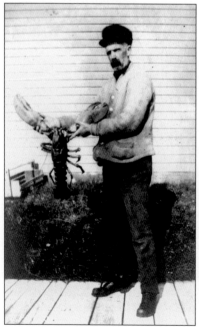

Eldridge Stone of Port Clyde holds a 10-pound lobster caught on August 12, 1914. The creature measured 36 inches between claw tips. Stone later gained a prominent place in local lore by driving a car on the iced-up St. George River from Port Clyde to Thomaston and back in 1923.

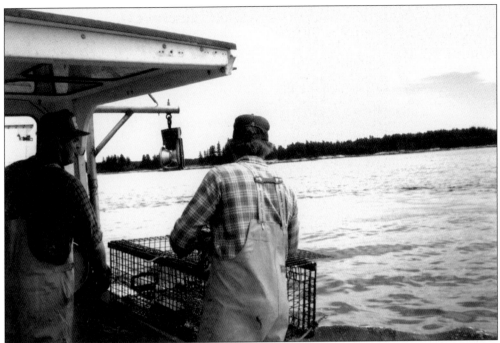

In the photograph above, lobsterman Alan Miller (left) and his sternman, Alan Knowlton, check their traps in Wheeler's Bay on a summer day in 1991. After removing the catch and old bait (below), they reload the traps with pogies (a type of herring also known as menhaden). Nowadays, lobstermen have increased the number of traps they set. As a result, they check their traps less often and use greater quantities of bait.

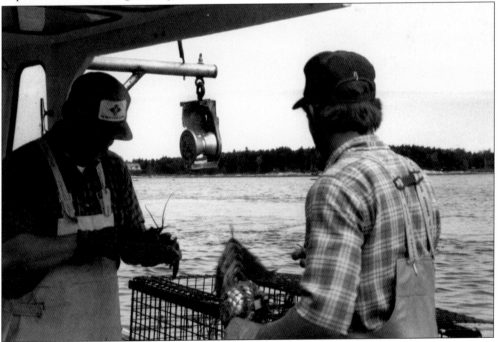

Once a common sight in St. George, smelt shacks provided a source of free food during long, frigid winters. These photographs of Otis Cove date from the 1940s.

At low tide in spring, fishermen would check their fykes (nets), used for catching two-inch-long juvenile eels (or elvers). Known as glass eels for their transparent skin, these tiny creatures are shipped to China and Japan, where they are considered an aphrodisiac.

High tide brought the elvers into the nets, where they would remain until collected at low tide. By the mid-1990s, stricter marine environmental regulations, declining harvests, and hefty gear prices shrank the eeling industry. Most of the nets are now gone.

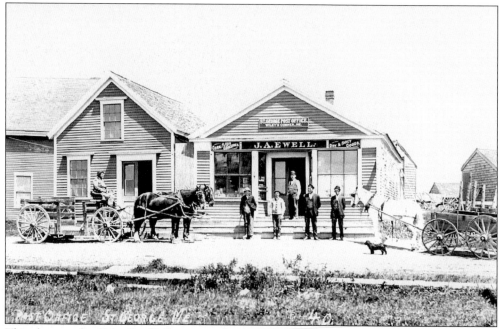

This photograph of John Ewell's Store was taken at Wiley's Corner in the late 1800s. The St. George Post Office was also located in this building. The horse and wagon were used to make deliveries. Customers who could afford to own a horse and carriage would come into the store about once a week—on roads that were very rough—to get their mail, groceries, and the latest gossip.

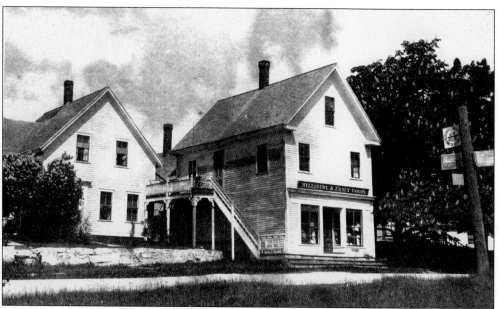

In downtown Tenants Harbor (across from the present-day post office), Mrs. Monaghan's Millinery and Fancy Goods store was located between Red Monaghan's home and the Masonic Lodge. (Courtesy of Marion Watts.)

For 50 years, the Tenants Harbor Post Office was located in the back of Ernest Rawley's Insurance Company. It closed down at 5 p.m. on December 31, 1969, when the newly built post office took over the service.

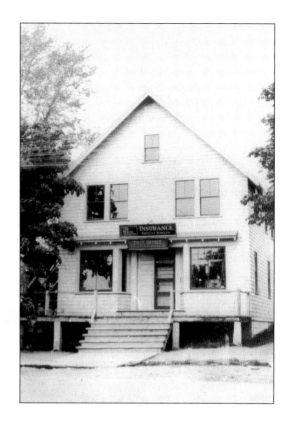

ERNEST RAWLEY

INSURANCE

FIRE, LIFE, HEALTH, ACCIDENT

NOTARY PUBLIC

TENANT'S HARBOR, MAINE

This advertisement shows the many services that Ernest Rawley offered from his business pictured above. He also sold groceries and operated the post office.

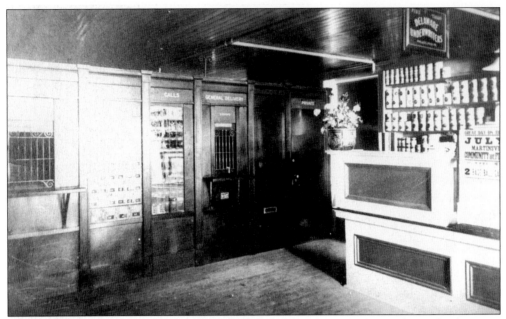

This 1918 photograph shows the inside of Ernest Rawley's store, which once housed a dentist's office and a private residence. In the late 1990s, after being vacant for many years, the town of St. George purchased it. In March 2005, it was deeded to the Jackson Memorial Library Committee to become the future home of a new public library.

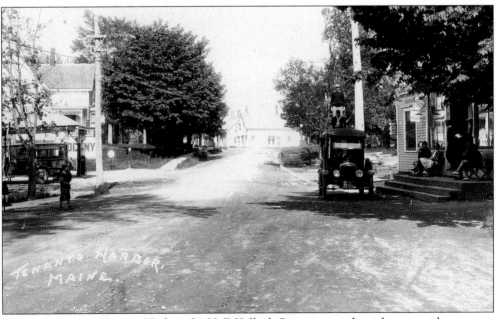

On Main Street in Tenants Harbor, the H. F. Kalloch Store was on the right; across the way was Alvah Harris's Garage. (Courtesy of Marion Watts.)

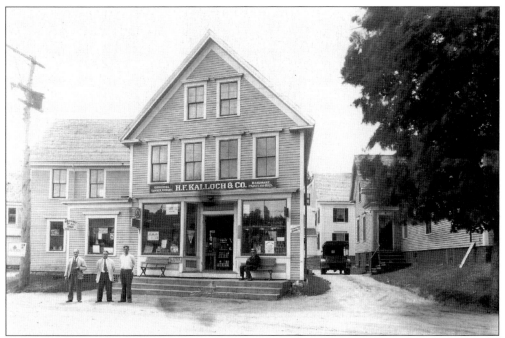

The H. F. Kalloch Store was located across the road from Alvah Harris's Garage. Deacon Henry F. Kalloch established the store in 1893, together with his son-in-law Elmer E. Allen. The store remained in the family until it closed in the early 1960s. Lumber and building supplies were located in the building that is now Farmer's Restaurant. The main store was torn down in the mid-1960s.

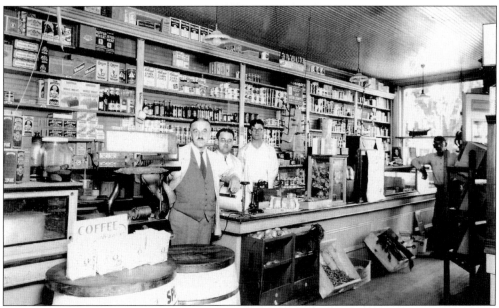

Like stores in all the villages of St. George, the H. F. Kalloch and Company Store was a full-service business. It sold lumber, building supplies, paint, hardware, and groceries. Kalloch's would also take customer orders for groceries and other supplies and then deliver the goods around town by horse-drawn wagon.

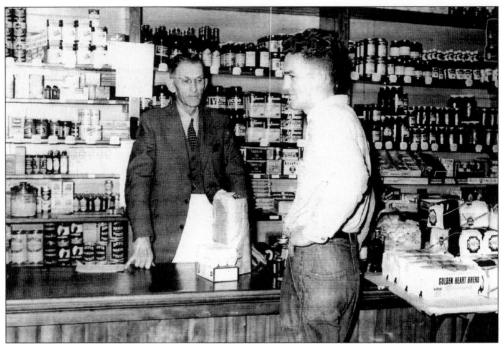

This 1940 photograph gives an interior view of the J. A. Ewell Store, located at Wiley's Corner. John Ewell ran the store for many years, later turning the business over to his son Henry and his son-in-law Capt. A. H. Thomas. Here, Thomas stands behind the counter while his grandson Donald Hawkins makes a purchase.

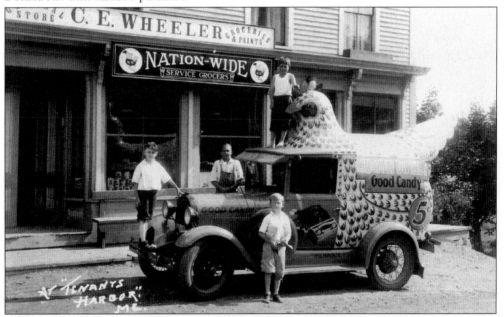

Charles Wheeler's Store was originally located on the waterfront in Tenants Harbor. Later, Wheeler moved the business up the hill to the Rawley building, located between Lowell's Garage and Hall's Market. The Chicken Van came into town as a promotional gimmick, causing excitement and great interest among all the local children.

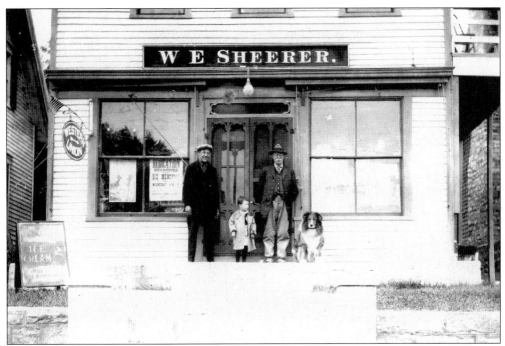

William Sheerer's Store was located on Main Street in Tenants Harbor, next to what is now the Dehlinger House. Sheerer is pictured here (right) in front of the store with his only son, Leroy (left), and his granddaughter Marguerite. Leroy assumed the day-to-day business operations when his father's sight started to fail. Also in the photograph is Prince the dog.

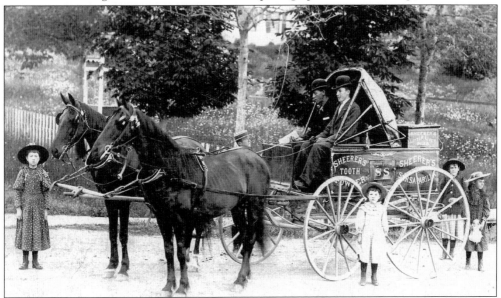

Humorously known as "Father Salve," W. E. Sheerer was in business for over 75 years. Not only did he run the store, he was also an inventor. Sheerer's sarsaparilla was a popular drink at the dawn of the 20th century, and his salve was said to cure many ailments. A Western Union office operated out of the store for 71 years and a post office for 36 years. Sheerer performed barber duties as well, with haircuts costing 25¢.

This is the whole City.

This photograph, taken around 1910, shows Village Road in Spruce Head. On the left is the longtime post office, discontinued in the 1980s when a new one was built around the corner. Behind the tiny post office is a private residence. In the background is the spire of the Spruce Head Church.

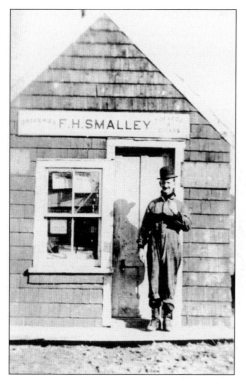

Fred Smalley stands outside his small "little-of-everything" store in the early 1920s. Catering to quarry workers and fishermen and their families, such entrepreneurial shops were located in every settlement on the St. George Peninsula. Smalley, who also served as a selectman and a school bus driver, came from one of St. George's oldest families; the Smalleytown settlement was named after the clan.

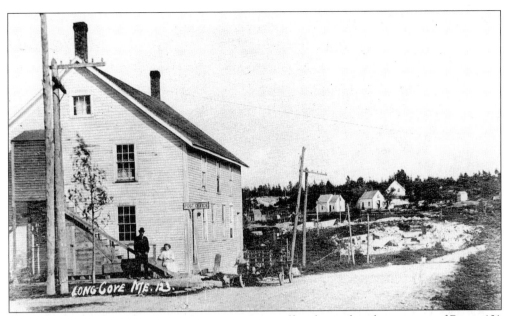

The heart of the Long Cove settlement was its post office, located at the junction of Route 131 and Long Cove Road, until it was demolished in September 1946. Here, the mail truck waits out front.

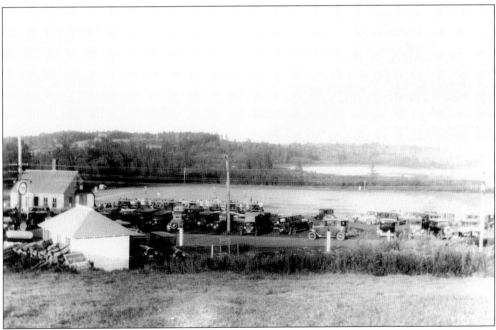

The ball field is in full operation. The white house on the left is Ruth Barter's Luncheon, and across the road, near the third base line (center left), is a part of a granite column. It was rigged for towing behind a truck and used as a roller to groom the field.

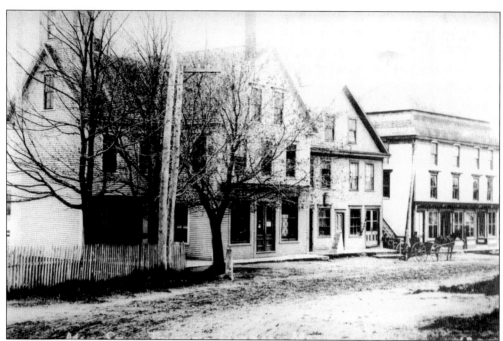

Much has changed in the building (left) that now houses Hall's Market on Main Street in Tenants Harbor. It was originally called Lew Whitehouse's. The building next to it had incarnations as an ice-cream parlor and a pool hall. In 1924, John Morris moved this building down the street next to a friend's house. Eventually, it was torn down, and John's son used the lumber to build a house for himself. At far right was the Lowell Brothers Garage, now a private residence.

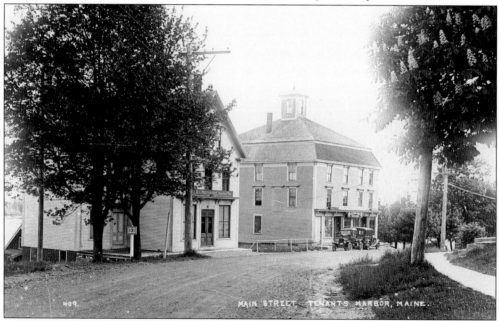

On Main Street in Tenants Harbor, newfangled automobiles sit outside George Rawley's Store, which later became Chick Wheeler's. Still later it was the Lowell Brothers Garage. The upper floors were removed when the building became a private residence.

The Drift Inn was a destination for natives and tourist alike. Located on the beach, a shore dinner was a certainty.

The long-gone Drift Inn opened in 1924 on what is now Drift Inn Road, just south of Mosquito Harbor. Several vacation cottages now occupy its former location, conveniently close to Drift Inn Beach, a wildly popular sandy spot at low-to-mid-tide on a hot summer day.

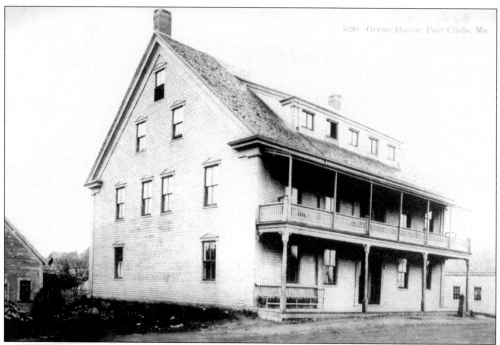

Since the early 19th century, the Ocean House in Port Clyde (above) has been a way station for travelers and a popular local gathering spot. It remains so today, with a building exterior that has changed little. Even during Prohibition (below), locals knew to come here for a tipple. Its longest-running owners were Fred Seavey and his wife, Rose. Other owners were Jim and Phoebe Brennan; today, the Ocean House is owned by Bud Murdock.

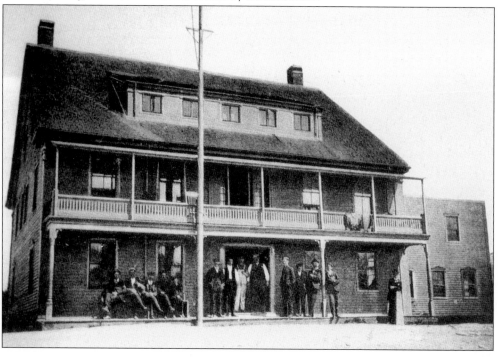

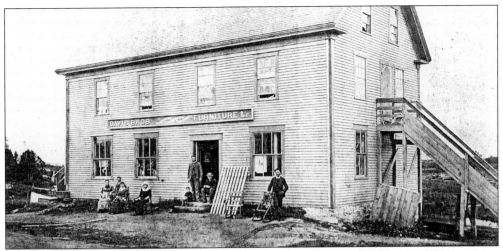

This building, located at Bickmore's Creek since the early 1800s, was used as a sail loft, serving a shipyard owned by John Bickmore. John is credited with building two brigs, one bark, and seven schooners. Also serving as a furniture store, the building still stands today and is now the home of the Grace Institute. Next door, George Morton owned a blacksmith shop that made parts for the shipyard. Today, it is used as a classroom to teach woodworking to students from St. George School.

An interesting place for entertainment in the summer of 1926 was the Ding Dong Dance Hall. Built by Mr. Pierson on a small plot of land near the Smalleytown intersection, it consisted of a wooden dance floor covered by a large canvas tent. During the summer and fall, all went very well. But come winter, the tent was ripped by the wind, and the water ruined the hardwood floor. The Ding Dong was no more.

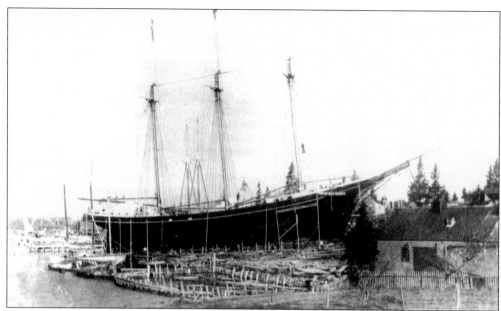

The handsome three-masted schooner *James W. Balano*, built in Port Clyde in 1894, was the centerpiece of *The Log of the Skipper's Wife*, published in 1979 by James W. Balano, son of the boat's namesake. The book recounts the seagoing adventures of Dorothea Moulton Balano, who accompanied her husband on his Atlantic trade route. In the foreground is the blacksmith shop that turned out metalwork for the ship. The Port Clyde Fishermen's Co-op now stands on the site of the defunct shipyard.

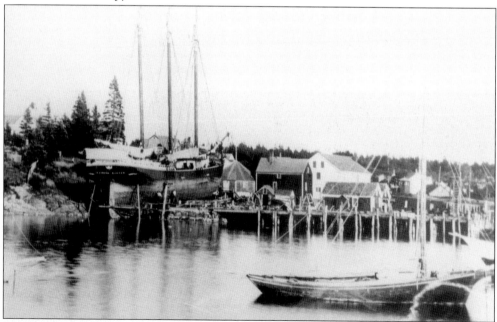

This larger view of Port Clyde Harbor gives another perspective of the *James W. Balano* as it is being built in 1894. Many schooners, brigs, barks, and sloops were constructed in St. George throughout the 1800s. Well over 200 have been recorded. No doubt many more vessels were built in the area's bustling villages, but no records have been found.

SCHOOLS AND SPORTS

TOWN TALK.

Vol. 1. Tenant's Harbor, St. George, Maine, Wednesday, November 17, 1886. No. 17.

'CONSIDER THE LOW PRICES
—AT THE—

St. GEORGE CLOTHING HOUSE

My Famous School Shoe, sizes 5 to 7	$.85
" " " sizes 8 to 10½		.95
" " " sizes 11 to 2		1.15
Ladies' Kid Shoes, 10-button, good style, wears well		1.25
Ladies' Serge Congress		.90
Ladies' French Kid		3.50
Men's Calf Boots		2.50
Men's Congress Shoes		1.25

I ACKNOWLEDGE NO RIVAL IN TOWN.

Subscribers seeing this notice marked will know that their subscription has expired and will be kind enough to remit promptly.

Written for Town Talk.
AUTUMN THOUGHTS.

I sit on the brown old hill-side; the setting sun
 behold;
I see the green old mountains, so beautiful,
 grand and bold;
I gaze on the trees below me, with their leaves,
 some green, some gold,
It reminds me that life is passing, that we are
 growing old.

As I gaze the leaves are falling; yes, falling
 one by one,
It fills me with a sadness; for I know my time
 will come,
When I, like the leaves that are falling, to meet
 their wintry bed,
Will have passed away to another world, and
 be numbered with the dead.

While I look the scene is darkened: a cloud
 obscures the sun;
It brings to my mind the river of death, when
 our earthly course is run.
But, my friends, when we've crossed that river,
 and our work on earth is done,
For those who have done the Master's will,

exchange which producers are entitled to, free of cost, at the hands of their own government.

Co-operative associations transact immense business, and exchange millions of dollars' worth of property of costless checks of their own coinage.

A nation of laborers, of different occupations, who require the products of each other's skill, is simply a national co-operative association.

In America every laborer and producer has a voice in legislation.

The laws and policy of the country may be just what they choose to make them.

The profits of merchants or middle men who buy or sell, may be limited by statute, as usury is.

The compensation for transportation should be limited to cost.

The medium of exchange should consist of the people's costless checks in

It is time for back-to-school shopping in 1886. Note the low prices at the St. George Clothing House. New school shoes were less than $1. Today, even shoelaces cost more than that.

This photograph of the Wiley's Corner settlement, located between Route 131 and the St. George River, shows, from left to right, the Wiley's Corner Post Office, which closed in the late 20th century; the St. George Grange (still used for Grange and historical society meetings); and the District 1 schoolhouse, built in 1889.

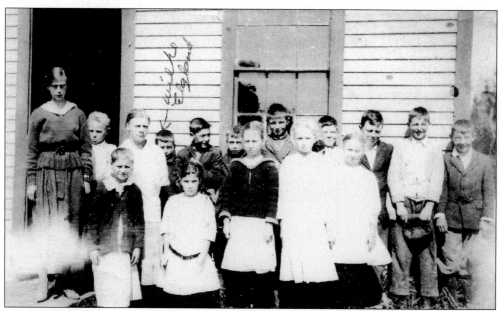

Smalleytown School, built around 1892, was located on Englishtown Road. The schoolhouse burned to the ground around 1917, and the children were then sent to the Long Cove Quarry Workers Union Hall for classes.

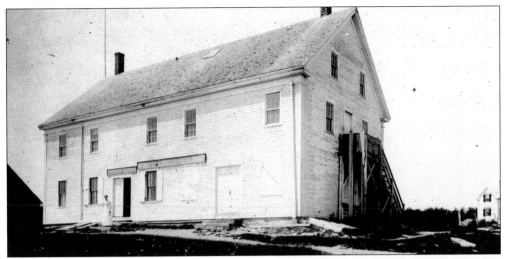

The first St. George High School is pictured here in 1896. Long's Sail Loft occupied the first floor. Sail making and sail repair where essential skills in Tenants Harbor, which depended heavily on working schooners and commercial craft. The school was housed on the second floor, with 38 students and W. H. Matthews doubling as teacher and principal. This building, overlooking the busy town harbor and public landing, is now a private residence.

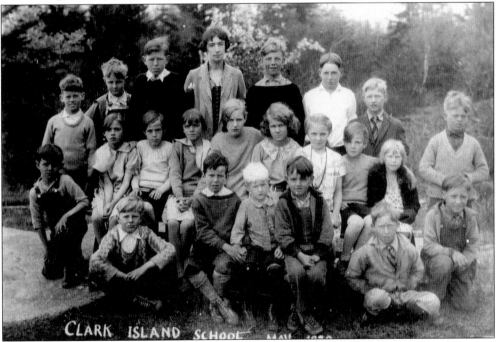

Clark Island School students pose in 1930. Seen here, from left to right, are the following: (first row) Herbert Maker, Edwin Baum, Albert Lind, Glenn Simpson, Arthur Lind, and Albert Putansu; (second row) Leslie Simpson, Catherine Caven, Minerva Johnson, Doris Caven, Greta Lind, Margaret Rogers, Marion Larson, Shirley Johnson, Alice Lind, and George Ellis; (third row) Raymond Ellis, Charles Simpson, Sven Larson, teacher Adrea Bartlett, Kenneth Morrison, Harrison Coolbroth, and Harry Lind. This one-room schoolhouse catered to numerous pupils from the same families.

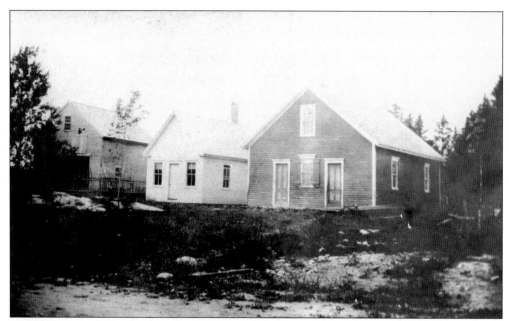

The above late 1800s photograph shows two schoolhouses at this location, with Reed Pierson's barn at the far left. The white building became part of the old town office. Then, joining the school from Clark Island, moved to the harbor around 1903. The building to the right was moved to Long Cove and became the post office. In the photograph below, the building to the far left looks more like a school than a barn, and there are signs of construction of the high school.

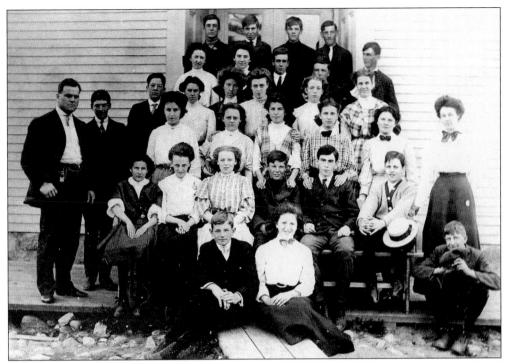

The student body of St. George High School gathers in the spring of 1909. On the left is principal G. A. Cowan; on the right is his assistant, Harriet Rawley. Long skirts were the fashion of the day for the young ladies. The young men look dapper in their suits and ties.

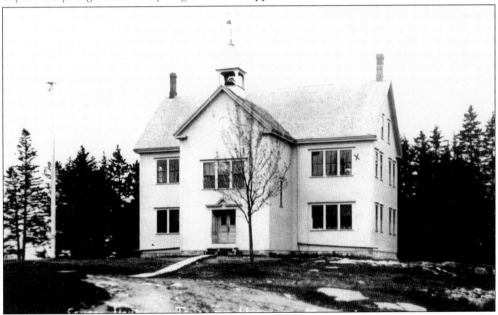

St. George High School in Tenants Harbor, seen in this view, eventually served students from all the small villages. At one time, the town had as many as 19 district schools. Now, all students from kindergarten to eighth grade attend the same elementary and junior high school. They then attend high school at Georges Valley in Thomaston.

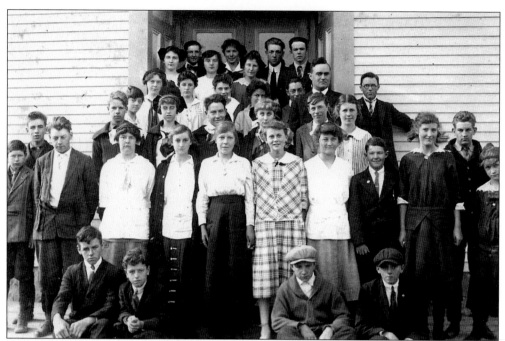

In this 1916 photograph, the entire freshman, sophomore, junior, and senior classes of St. George High School pose with teacher and principal G. A. Cowan. Among them is Albert J. Smalley, a historian and writer whose book, *History of St. George, Maine*, is still the most complete account of the town. (Courtesy of William Hickey.)

The old St. George ball field was behind the sail loft where the Little League plays now. The diamond was angled somewhat differently and two of the homes in the outfield were not yet built.

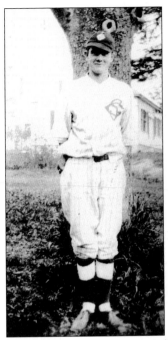

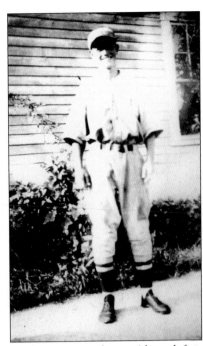

The 1927 St. George High School baseball players show off their new uniforms. Above left is Sam Archer, and above right is Maynard Wiley. Below are Lewis Benner (left), Merrill Chadwick (center), and Henry Lowell. Some of these players were also regulars in the games for the Knox County Twilight League, of which St. George was the 1930 champion.

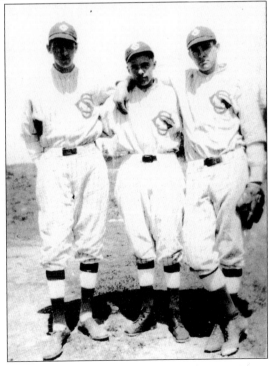

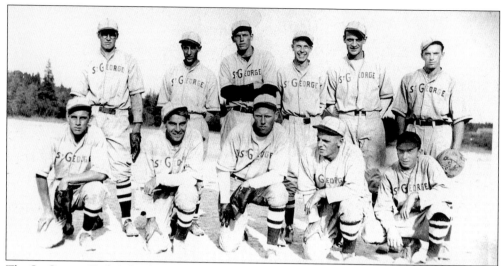

The St. George High School baseball team appears in 1931. Pictured here, from left to right, are the following: (first row) Maurice Simmons, Sony Dwyer, Sewde Westburg, Howard Monahan, and Soddy Feyler; (second row) Henry Lowell, Spider Simmons, Van Shreiber, John Davidson, Bart Morrisey, and Sump Archer. The main pitchers were Maurice Simmons and Henry Lowell. The following year, Maurice pitched 9-2 and batted a .440 to lead the league. Henry was 9-1, as he could never play on Saturdays; that day he worked at Alvah's Garage.

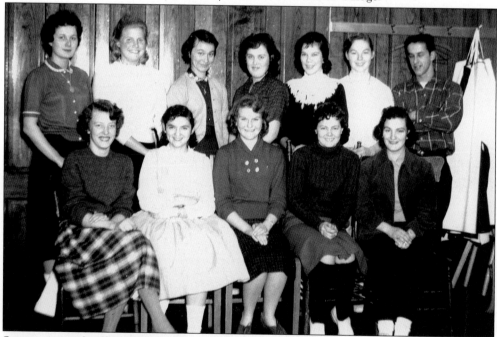

Sports were and still are an important part of St. George School. The 1959 girls' softball team consisted of the following, from left to right: (first row) Mary Seely, Judy Hupper, Shirley Swanson, Carol Wall, and Irene Eaton; (second row) Carolyn Smith, Gail Makinen, Carolyn Taylor, Karen Kallio, Barbara Johnson, Bonnie Gregory, and coach Billy Anderson. The wooden panels in the background separated the laboratory (note the aprons) from the main part of the room. The panels were removed when a larger space was needed.

84

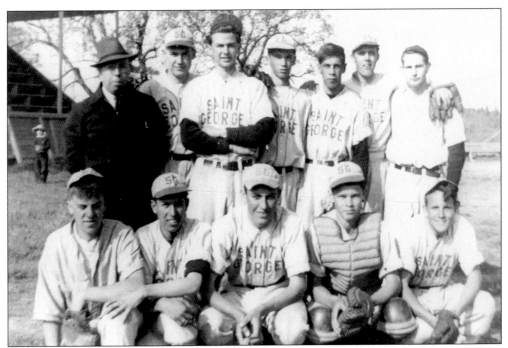

The St. George High School baseball team of 1940 included John Melquist (first row, far left), who was killed in Europe on December 24, 1944. The Tenants Harbor American Legion Post is named for him. Others on the team were as follows, from left to right: (first row) Edwin Baum, Hilding Seastrom, Preston Wiley, and Bartlett Johnson; (second row) principal and coach Clayton Hunnewell, Richard Kallio, Raymond Jacobson, Malcolm Wiley, Hazelton Mclaughlin, Alfred Kinney, and Victor Blomberg. The boy in the back by the grandstand is Bradley Wiley.

The new ball field on Route 131, just before Hart's Neck Road, was dedicated on July 4, 1931. This photograph was made from negatives found in Earl Barter's house after ownership changed in 1991. The images show Barter's garage and, across the road, the Dodge-Hall farm. Later, those buildings were torn down and bleachers were erected along the base line.

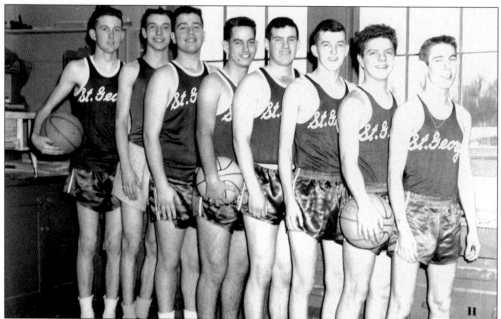

At first, St. George had no basketball team, no coach, and no gym, but in 1959–1960, Don Holmstrom and Gary Harper organized one, with Don likely self-elected coach. Team members bought their own uniforms and took part in the Rockland Recreational League. They also played unscheduled games with Thomaston, Warren, Union, and North Haven schools. Seen here, from left to right, are Ronnie Ames, Tim Holmes, Gary Harper, Gary Austin, Don Holmstrom, Richard Minzy, Joel Link, and Linwood Small.

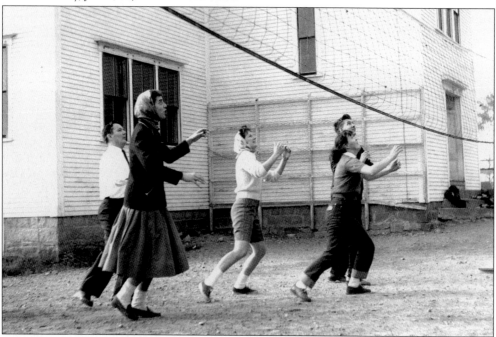

Identified here, a volleyball practice occurs with commercial teacher Robert Trembley (in the rear), Amy Cook, Carolyn Smith, and English teacher Warren Loveless.

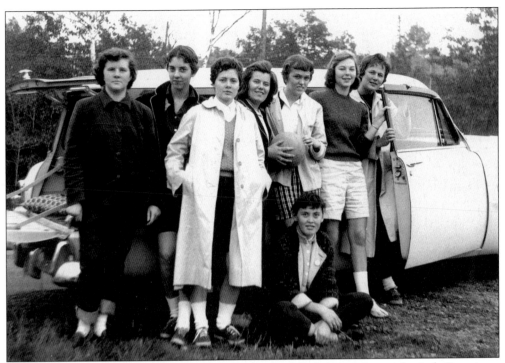

The 1959 St. George High School volleyball team included, from left to right, Judy Dennison, Amy Cook, Carol Wall, Judy Smith, Barbara Jarrett, Bonnie Gregory, and Carolyn Smith, and Karen Kallio (seated).

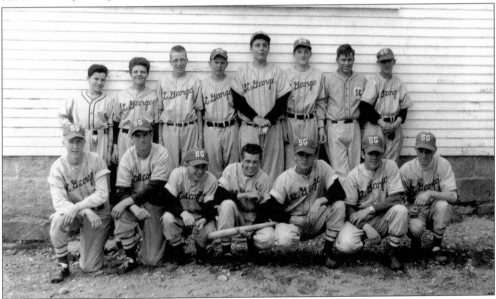

Medomak Valley League rules required batting helmets for the first time in 1958. Here, posing for the baseball team photograph are the following, from left to right: (first row) Neal Hupper, Don Holmstrom, Floyd Conant, Steve Jarrett, Larry Anderson, Bernard Davis, and George Fay; (second row) Irving Bracey, Joel Link, John Hawkins, William Hill, Gary Harper, Richard Minzy, Alvar Hyvarinen, and Linwood Small.

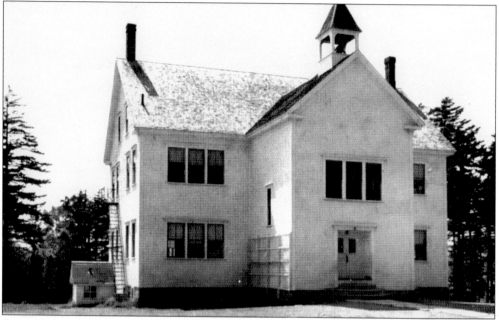

Construction on the new St. George High School in Tenants Harbor began in 1899 and was completed in 1900. The first class graduated in 1901. The high school occupied the second floor and the elementary school the first floor. In 1956, a new elementary school was built to house grades one through six, but the seventh- and eighth-graders remained in the old building until the late 1960s.

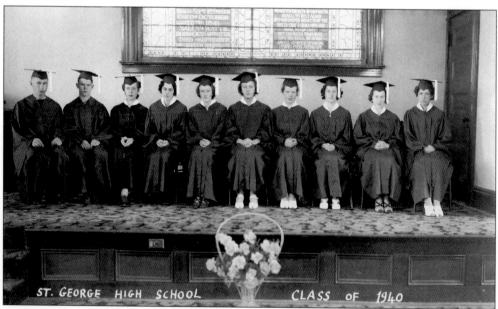

The class of 1940 is seen in this photograph, taken at the Tenants Harbor Baptist Church. The graduation ceremony occurred at the church; not only did it offer more space, it also provided a more formal setting. Note the number of girls (eight) to boys (only two). Pictured here, from left to right, are John Holgerson, Preston Wiley, Rachel Robinson, Betty Imlach, Margaret Troupe, Agnes Davis, Ella Bald, Gertrude Breen, Laura Daniels, and Arlene Coolbroth.

BAND
JAMBOREE

Rockland Community Building
Tuesday, May 1, 1951

FEATURING

School Bands of

St. George Thomaston
Rockland Rockport
and
50-Piece Composite Band

SPONSORED BY

J. Weldon Russell	Supt. Schools, Rockland - Rockport
Joseph Blaisdell	Supt. Schools, St. George
Lindon Christie	Supt. Schools, Thomaston

This 1951 advertisement promotes a band jamboree. The high school band was important to the community, as well as to the school. It served the town at parades, concerts, shows, and suppers. Its members also traveled to events in other towns.

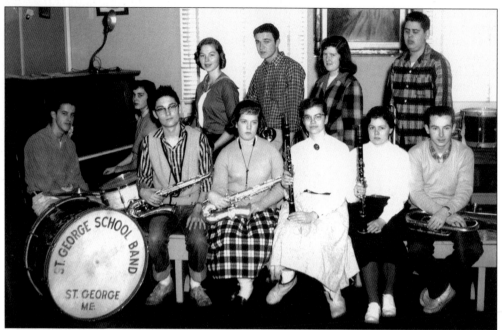

The St. George High School dance band was organized and directed by Vere "Chum" Crockett of Camden in 1958. The group gave its first concert at the Odd Fellows Hall in Tenants Harbor that year. John Parker became the director in 1959. By then, music stands had been bought, and the band called itself the Harbor Light. Practice took place in the community room of the Grace Institute. Shown here are the following members, from left to right: (first row) Bill Anderson, Ronnie Anderson, Janice Bryant, Sandy Moon, Carol Wall, and Floyd Conant; (second row) Susie Cook, Bonnie Gregory, Larry Anderson, Lorna Hupper, and Frank Grant.

Two band members show off their new uniforms around 1951. Both Robert Dennison and Lorraine Thomas took part in the band jamboree. Robert played the clarinet and Lorraine the saxophone.

90

St. George High School students act out the events of history in 1959. Everyone wants to be a cowboy, agree Linwood Small, Neal Hupper, Larry Anderson, and Steve Jarrett.

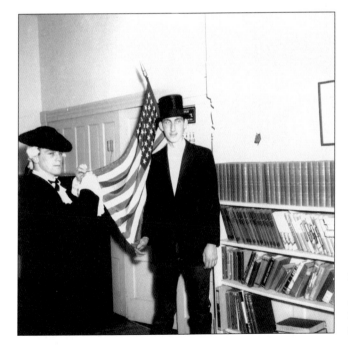

A short but handsome George Washington and a young, tall Abraham Lincoln honor the flag, acted by George Fay (left) and Melvin Davis.

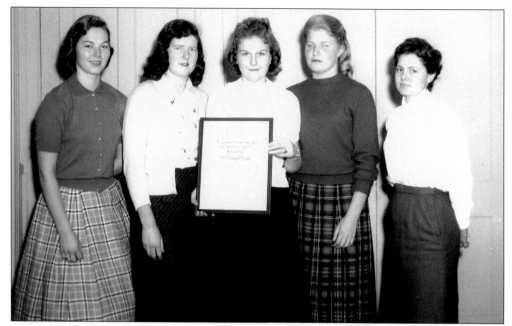

The St. George chapter of the National Honor Society was chartered on March 6, 1958, but students were not selected for membership until the following year. The charter members were, from left to right, Bonnie Gregory, Lorna Hupper, Shirley Swanson, Gail-Donna Makinen, and Carol Wall. They were inducted at a ceremony held at the Medomak Valley League level.

The freshman class performed the one-act play *Say Uncle* in 1958, and rehearsals were held in the Odd Fellows Hall. Pictured here are the following, from left to right: (first row) Barbara Savoy, Sandy Moon, Tim Holmes (guest appearance), and Brian Cook; (second row) Sally Field, Joyce Stanley, and Adrian Polky. Commercial teacher Robert Trembley directed.

This photograph was taken at the reception held by the freshman class in 1958. Seen here, from left to right, are the following: (first row) Judy Smith; (second row) Sandy Moon, Sally Field, Joyce Stanley, Barbara Savoy, Sally Jo Long, Priscilla Cushman, and Linda Davis; (third row) Brian Cook, Joe Theriault, David Salmi, and Fred Weller. Alone in the back is Adrian Polky.

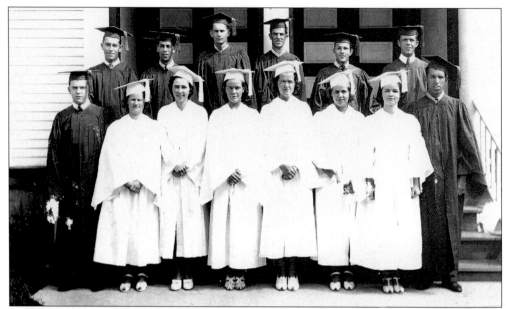

The St. George High School class of 1941 included the following, from left to right: (first row) Malcolm Pierson, Lempi Hill, Frances Mills, Shirley Johnson, Virginia Kinney, Marion Dowling, Marion Seavey, and Edwin Baum; (second row) Hilding Seastrom, Hazelton McLaughlin, Victor Blomberg, Henry Melquist, Bartlett Johnson, and Alfred Kinney. Note the more elaborate costumes and the increased number of boys. In 1949, the number of graduates was once more down to 12 girls and 2 boys. In June 1960, the Harbor Baptist Church was struck by lightning, and graduation was moved to the church at Wiley's Corner.

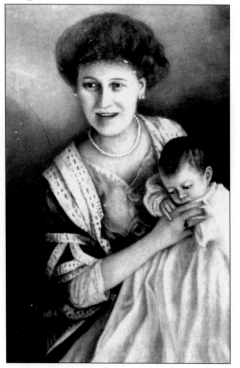

This painted portrait of Lillius Gilchrest Grace hangs in the resident's quarters of the Grace Institute in Tenants Harbor. She was the daughter of Capt. George and Mary Jane Gilchrest of Tenants Harbor.

The Grace Institute, located on Main Street in Tenants Harbor, was a gift to the town of St. George from the family of Lillius Gilchrest Grace. (Previously it had been the Davis Brothers Furniture Store.) Lillius, a St. George native, was the daughter of Capt. George Gilchrest, whose family accompanied him on his trading voyages in the Indian, Pacific, and Atlantic Oceans. Along the coast of Peru, Lillius met an enterprising young Irish man named William R. Grace, who had founded the W. R. Grace Shipping Company, dealing in bat guano, in 1854; they were married in 1859. William Grace later founded the Grace Lines and made a vast fortune in shipping and passenger service, focusing on Latin America. Lillius always retained an interest in her hometown, and after she died, her family established the Grace Institute in her name. Junior high school classes in domestic science, manual arts, and metalworking were held in these buildings until 2005.

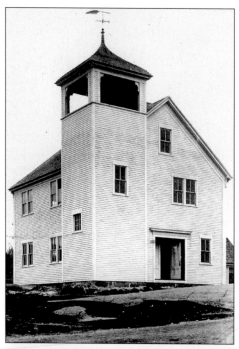

The Port Clyde School stood at the corner of Drift Inn Road and Route 131 as it enters Port Clyde (also called South St. George in the early 1800s). The school was closed in the mid-1950s, when the new St. George Elementary School in Tenants Harbor was opened. The Port Clyde School was razed in the late 1950s to allow for the New Stretch of road, a more direct route into the village.

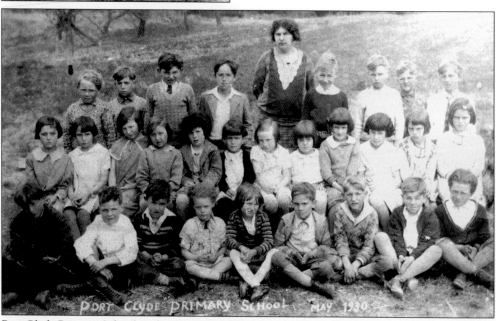

Port Clyde Primary School students pose in 1930. Identified here are Douglas Anderson, Winston Pease, Aaron Simmons, Evelyn Tracey, Gladys Davis, Russell Cook, Bernard Cushman, Bernard Davis, Albet Watts, Verena Davis, Agnes Davis, Marguerite Stone, Shirley Teel, Jean Anthony, Margarita Crouse, Madeline Simpson, Helen Anthony, Virginia Condon, Josephine Thompson, Pauline Thompson, Ned Stone, Shannon Cushman, William Davis, Bertie Simmons, teacher Norma Hawkins, Oscar Simpson, Sidney Davis, Clayton Pease, and Edward Davis. Each village in St. George had a school until the consolidation and creation of administration district No. 50 in 1956.

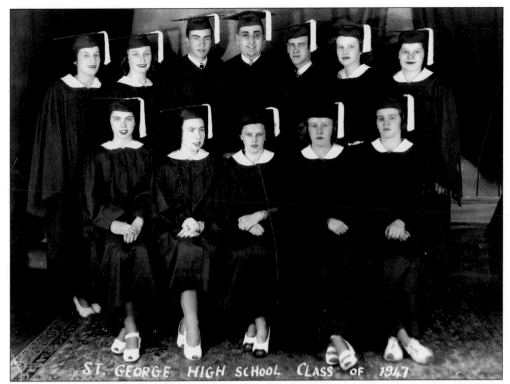

The St. George High School class of 1947 included the following, from left to right: (first row) Betty Dennison, Theo Hupper, Shirley Dwyer (Pierson), Kathy Anderson, and Jeannie Dorrie; (second row) Olive Cline, Lucille Stone (Wiley), Bill Black, True Hall, Bob Dorrie, Dorothy Lantz (Philips), and Shirley Fuller. Many from this class stayed in St. George to work and raise their families. (Courtesy of Dorothy Philips.)

In 1985, after the first floor of the high school had served from the mid-1960s to mid-1980s as a junior high school, the old building was torn down to make way for the new St. George Town Office. The fire station to the left of the office site (not visible) was later torn down and a new fire station was added below the existing town office.

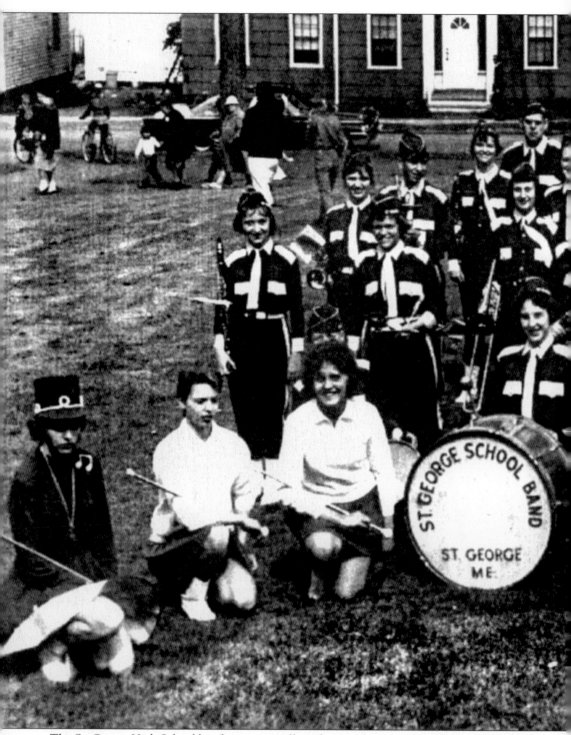

The St. George High School band appears in all its glory on the grounds of the Rockland Public Library on Memorial Day 1961, much to the interest of the people by the houses on Union

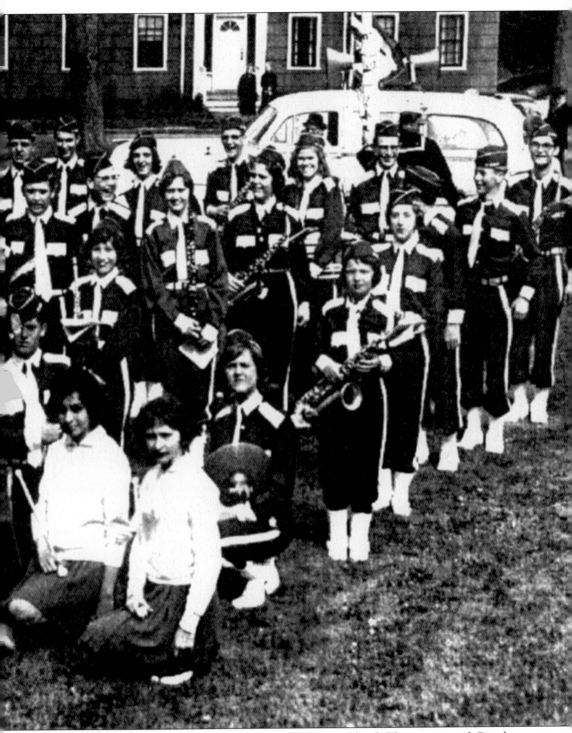

Street. The band played often in local towns, including Rockland, Thomaston, and Camden. (Courtesy of the *Courier Gazette*.)

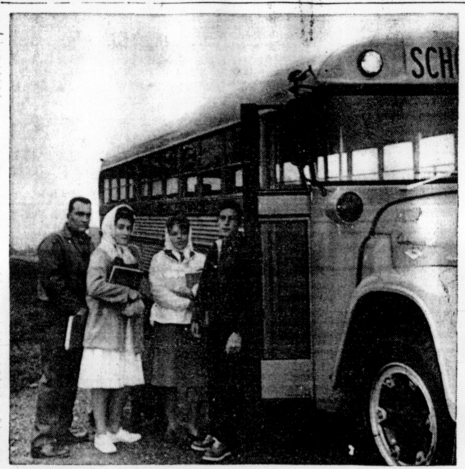

NEW BUS, NEW SCHOOL — Dana Smith, driver of the new Georges Valley High School bus from Tenants Harbor, stops to pick up his first students in front of the Forbes Taylor home in Long Cove shortly before 7 o'clock Wednesday morning. For the first time, the high school pupils in St. George will be attending a school outside their area. The tables are turned this year; last winter these students were among the last picked up as the busses headed toward the old high school at Tenants Harbor. This year, the boys and girls must "rise and shine" early as the Taylor home marks the first stop on the drive to Thomaston. Smith's route also covers Long Cove Road, Spruce Head, Clark Island and all of Route 131 between Tenants Harbor and Thomaston. Another bus in the area picks up pupils in Port Clyde, Martinsville and Tenants Harbor. Photo by Link

The new bus route taking high school students to Thomaston required a first stop 1.8 miles from Tenants Harbor, at the home of Forbes Taylor in Long Cove. The bus, driven in 1963 by former principal Dana Smith, picked up students from Clark Island, Spruce Head, Port Clyde, Martinsville, and Tenants Harbor. St. George, Cushing, and Thomaston have now combined to form School Administrative District No. 50. (Courtesy of the *Courier Gazette*.)

Six

LIGHTHOUSES

Ride the stagecoach to Rockland for a day of shopping and errands, or this company would do the work for you.

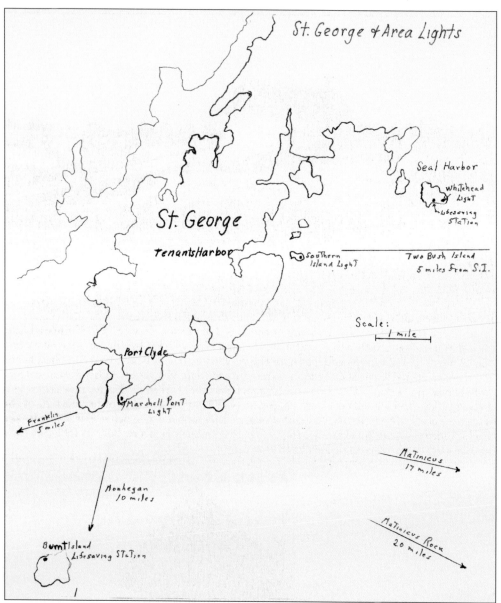

St. George & Area Lights

Seal Harbor

Whitehead Light

Lifesaving Station

St. George

TenantsHarbor

Southern Island Light

Two Bush Island
5 miles from S.I.

Scale:
1 mile

Port Clyde

Marshall Point Light

Franklin
5 miles

Matinicus
17 miles

Monhegan
10 miles

Matinicus Rock
20 miles

Burnt Island
Lifesaving Station

This basic map indicates the locations of many St. George lighthouses, the most well known being Marshall Point Light in Port Clyde.

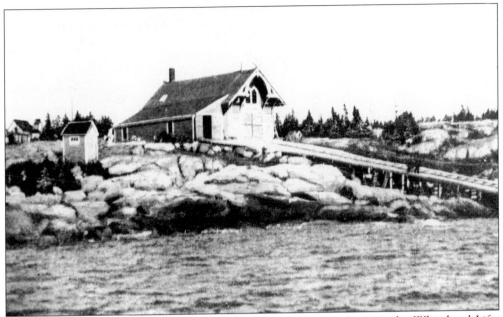

In 1874, three years after the founding of the U.S. Life-Saving Service, the Whitehead Life-Saving Station was established on Whitehead Island. The wooden boathouse (seen above and below) had a second-story sleeping area for the busy rescue teams. (Capt. Freeman Shea, famed commander of the Whitehead Station, assisted more than 600 vessels in his 35-year career.) This handsome building, listed on the National Register of Historic Places, now serves as a dormitory for the Pine Island Camp, a century-old summer camp that owns about 70 of the island's 90 acres. Under the Maine Lights Program, the camp has assumed responsibility for the much-needed restoration of the long-empty deputy light keeper's house, built in 1888 (the head light keeper's house was demolished in 1899).

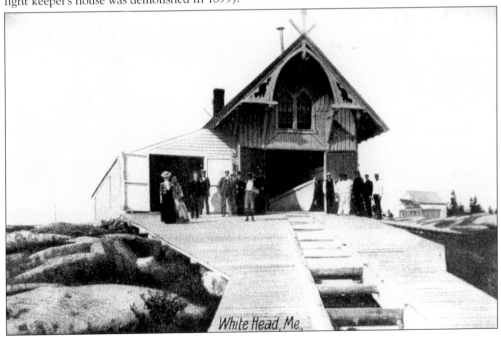

White Head, Me.,

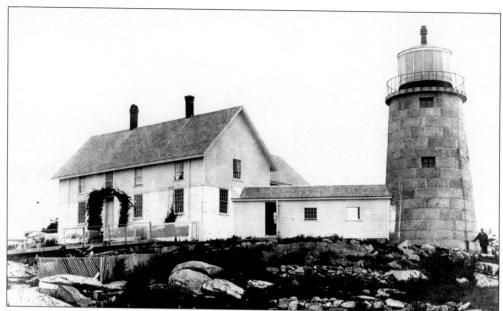

Shrouded in fog for an average 70 to 80 days a year, Whitehead Island—at the eastern entrance to the Mussel Ridge Channel in Penobscot Bay—was a logical location for one of Maine's earliest lighthouses. In 1803, Thomas Jefferson ordered the construction of Whitehead Light, which remained until 1852, when a new keeper's house and light tower were built. Whitehead Light was automated in 1982 and converted to solar power in 2001. (Whitehead was originally White Head until the U.S. Coast Guard assumed responsibility for lighthouses and other aids to navigation in the early 20th century.)

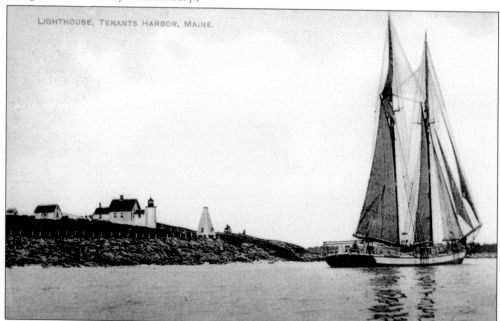

LIGHTHOUSE, TENANTS HARBOR, MAINE.

The elegant schooner *Merrill C. Hart* sails past Tenants Harbor Light on Southern Island. Although this photograph is undated, it had to have been taken sometime before November 8, 1909, when the *Hart* sank after a collision with another vessel off Block Island, Rhode Island.

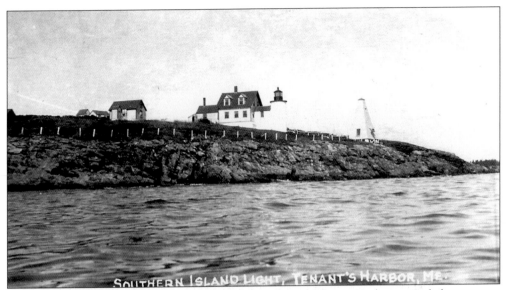

Tenants Harbor Light, standing on Southern Island near Tenants Harbor, provided protection for sailors from 1857 to 1933. Shown in this 1912 image are the oil house (built in 1906 for fuel storage), the keeper's house with its attached 27-foot light tower, and the bell tower. The first light keeper was Levi Smalley.

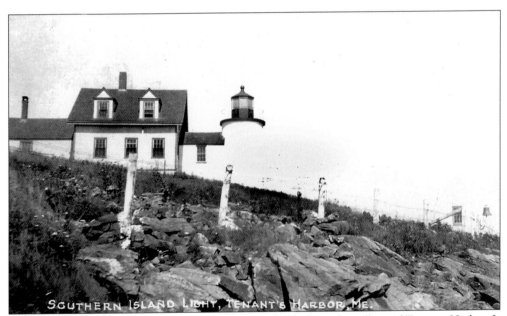

This is a closer view of Southern Island, which is visible from the village of Tenants Harbor. It has undergone some renovation, and the owners have added new buildings.

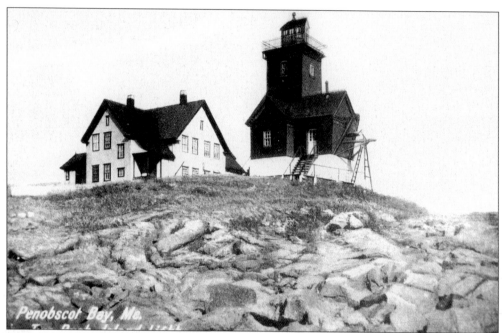

One of the newest lighthouses on the Maine coast, Two Bush Island Light was established in 1897 on a bleak, rocky islet about five miles off Tenants Harbor. Even the pair of pines for which the island was named has long since disappeared. The two-story house—home to keeper Leland Mann and his family for 14 years in the early 20th century—was demolished in a military training exercise in 1970. The distinctive 42-foot square light tower (below) is all that remains, its red light powered by solar panels installed in 2000. The light was automated in 1964; the U.S. Fish and Wildlife Service owns the premises.

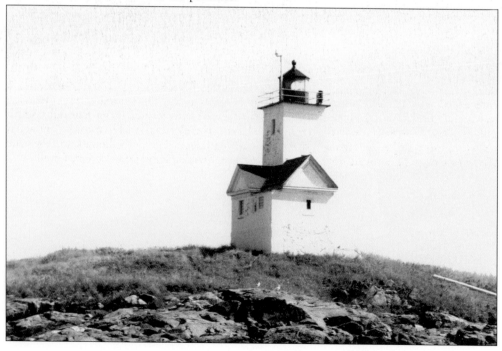

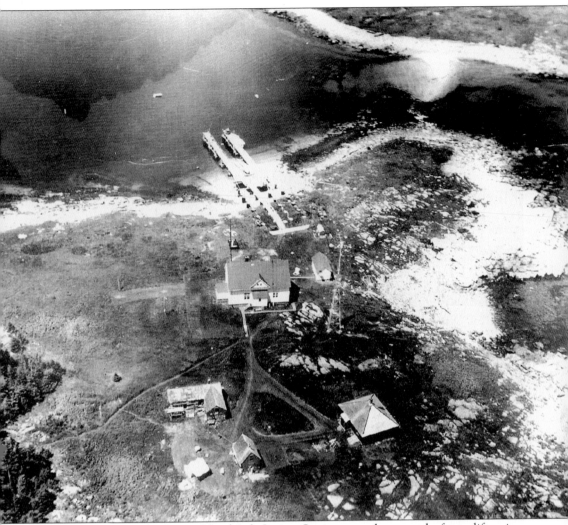

Established in 1891, the Burnt Island Life-Saving Station was the second of two lifesaving stations within St. George (the other being Whitehead). It is located about four miles south of Port Clyde, almost halfway to Monhegan. Among the elements visible in this 1939 aerial photograph are the keeper's house (center), a small boathouse (right of the house), and the ways (above) for easing the rescue surfboats into the water. The first keeper was Herbert Elwell.

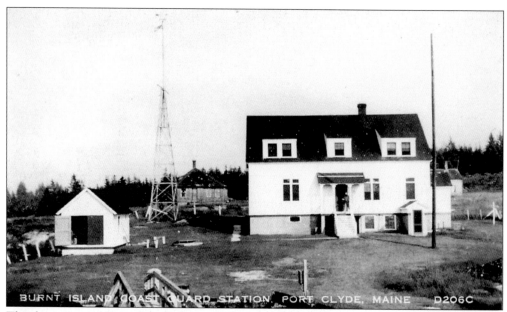

This later view of Burnt Island shows the keeper's house. The small building to the left is a boathouse. The Burnt Island Life-Saving Station was established in 1891 and did its bit toward the cause but in no way was it comparable to the active Whitehead Station.

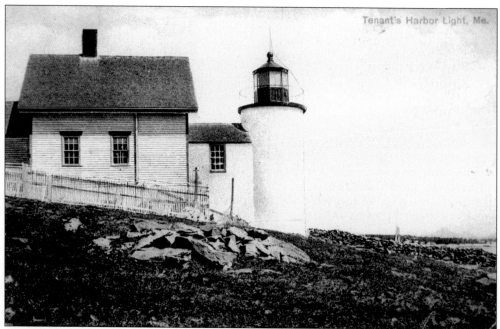

This 1909 photograph of Tenants Harbor Light shows the tiny passage linking the keeper's house to the light tower—a major advantage during wild winter storms, when tending the light was a life-and-death matter. In 1978, when the government decommissioned the light, noted artist Jamie Wyeth and his wife purchased the 22-acre island and its buildings. Jamie has featured the setting in a number of his paintings, and a replica of the original bell tower now serves as his studio.

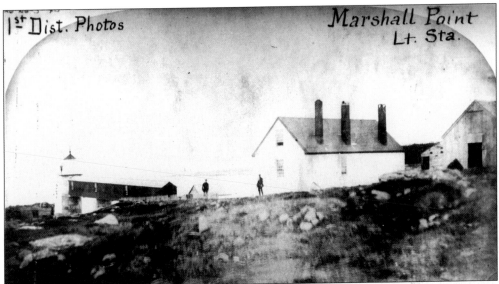

This 1859 image of the Marshall Point Light Station, guarding the entrance to Port Clyde Harbor, shows the current light tower and walkway. The original tower, built in 1832, had been attached to the keeper's house; both were built of granite and brick. The light consisted of seven reflector-backed lamps, requiring constant attendance by first keeper John Watts and others. It was electrified (with a wick-lamp backup) in 1921 and automated in 1971. The light now has a range of 13 nautical miles.

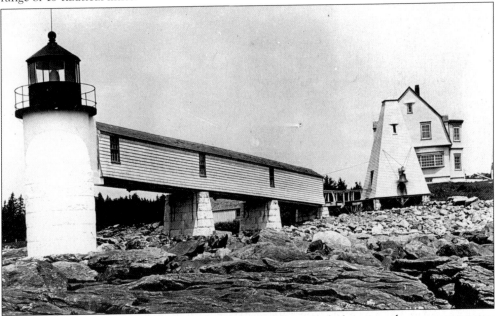

In this undated photograph, the walkway at Marshall Point Light has a wooden cover to protect the light keeper from the ferocious storms that slam this headland. The cover was removed in 1980. The bell tower (right of the walkway), built in 1898, operated much like a grandfather clock—the weight had to be raised by hand every four hours, and a hammer extended through the tower wall to strike the 1,018-pound bell every 20 seconds. Eventually, an electric motor was installed to perform this arduous task; a foghorn replaced the bell in 1969.

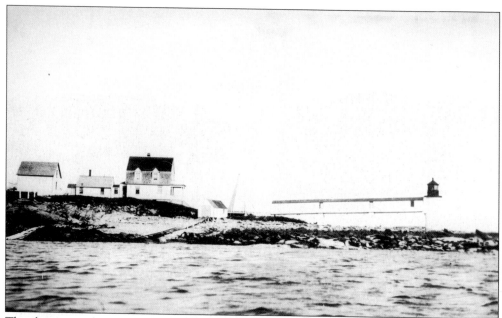

The above view shows the Marshall Point Light Station, as seen from Port Clyde Harbor. Below, a postcard image of Marshall Point, postmarked 1925, shows the summer kitchen to the right of the keeper's house. A small passageway connected the two buildings. The Marshall Point Light Museum, now occupying the summer kitchen and the adjacent first floor of the keeper's house, overflows with intriguing exhibits of local memorabilia assembled by the St. George Historical Society.

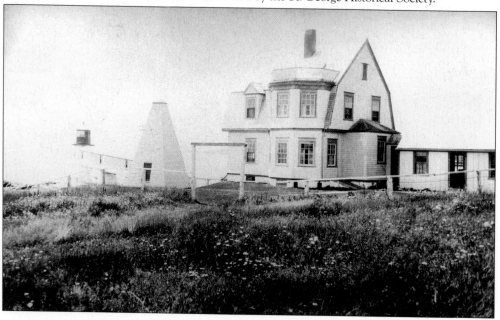

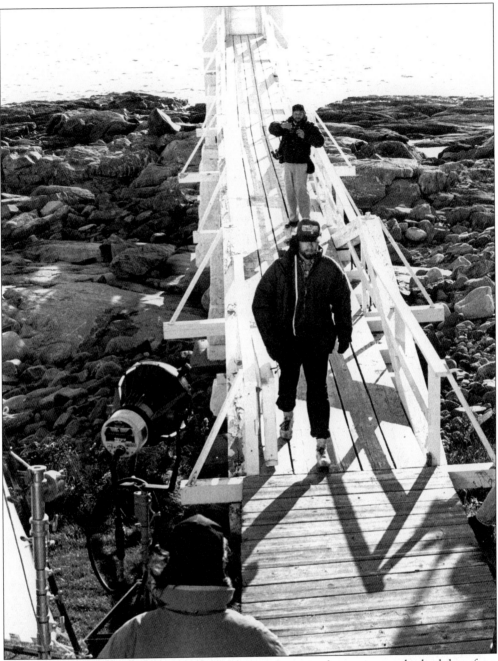

Marshall Point Light earned its own bit of national renown by serving as the backdrop for a scene in the film *Forrest Gump*. Facing the camera in the foreground is actor Tom Hanks, who earned a Best Actor Oscar for his role as Forrest. (Courtesy of Dana Smith.)

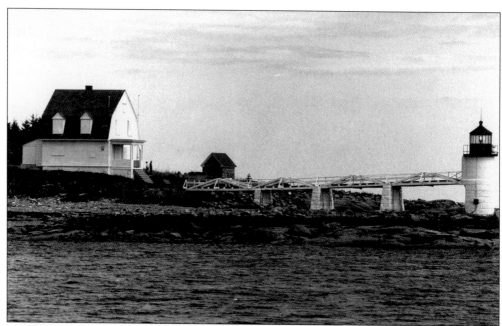

In January 1978, when the Coast Guard was using the Marshall Point keeper's house as a Loran station, a major storm ruined part of the walkway leading to the light tower; it has since been repaired. In 1971, the light was automated and the Coast Guard station closed. The keeper's house was little more than a boarded-up shell when the town of St. George rescued it from commercial developers in 1986 (when this photograph was taken). Ambitious fund-raising led to a total restoration of the town-owned keeper's house. Today, the building houses the Marshall Point Light Museum on the first floor and a caretaker's apartment on the second.

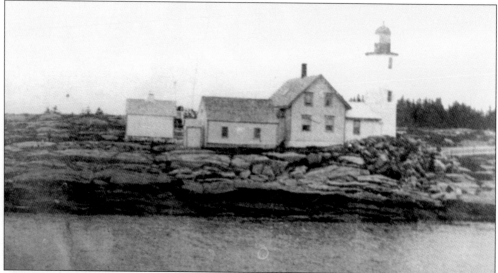

Built in 1803 but not occupied until 1807, Franklin Island Light was rebuilt in 1831 and 1855. The keeper's house shown in this 1891 image disappeared long ago; only the light tower remains on this isolated 12-acre island. The fixed white light—with a white flash every 90 seconds—was automated in 1967. Located in Muscongus Bay, Franklin Island is visible from Port Clyde but is not within the St. George town limits.

Seven

VILLAGE VIEWS

SOCIAL DANCE
At Martin's Hall, Martinsville,
Every Thursday Night. Tickets, 35 Cents

Social life in St. George was an important part of the community in the 1800s and early 1900s. Many halls, which are now gone, would host dances, band concerts, suppers, and plays.

Robert and Mary Polky pose with their eight sons (they also had six daughters). Pictured here are the following, from left to right: (first row) Albert, Charlie, Henry, and Walter; (second row) Julius, John, Robert, Mary, Elmer, and William. The Polkys' five-year-old daughter Signe died in a freak accident—struck by a rock fragment from dynamite operations in the Long Cove area. Insurance from quarry operators Booth Brothers covered the cost of building a new home for the Polky family at the junction of Route 131 and Long Cove Road.

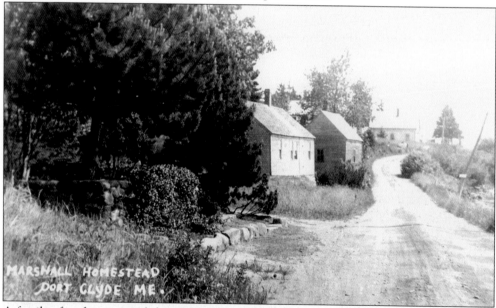

A family of seafarers owned these Marshall homesteads, located on the road that leads to the now-famous Marshall Point Light. Today, as one drives to the lighthouse, most of the original homes are gone, having been replaced with large summer houses. To the right, not visible, is a beautiful view of the Atlantic Ocean and islands.

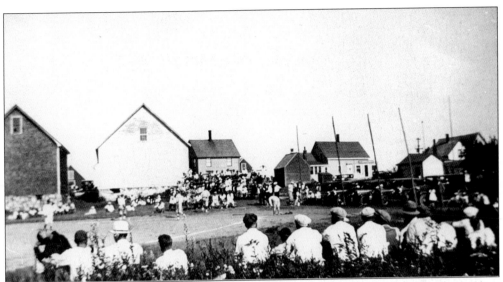

Baseball was often played at Clark Island. In the above photograph, on the right, the roof line of the quarry workers' boardinghouse (now the Craignair Inn) can be seen above the treetops. Spectators stood or sat on a makeshift granite bench. The tall poles in the background (above) held a net used to protect the nearby homes.

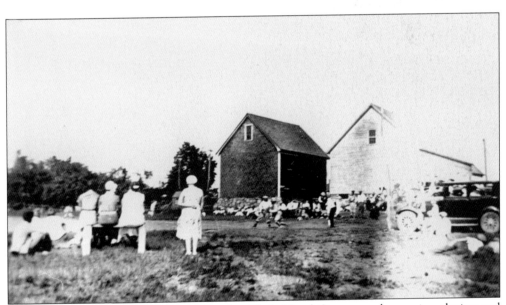

On a bright summer day in the 1930s, the Clark Island Quarry workers enjoy playing and watching a game of baseball. Several of the local quarries had baseball teams, which were part of the social life of the times.

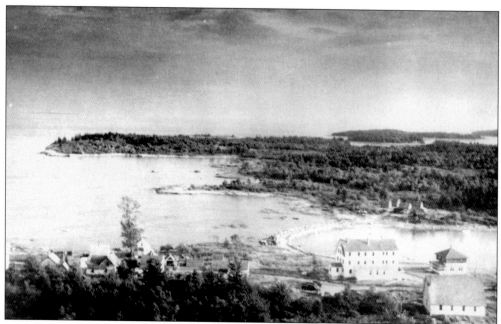

This 1949 aerial view displays the Craignair Inn and causeway to Clark Island in the village of Spruce Head. Once serving as a boardinghouse for local quarry workers, the Craignair has been renovated into a comfortable inn especially popular with hikers and birders.

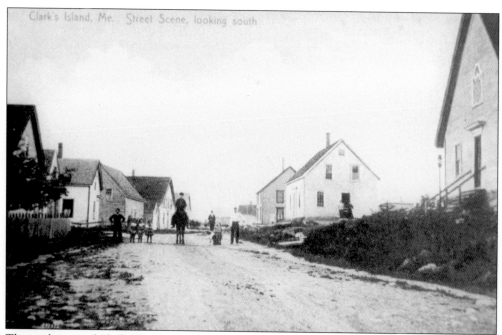

The settlement of Clark Island is seen here during its quarrying heyday. The large building at the right was the union hall for quarry workers. Behind the hall was a ball field used by the workers for many happy hours of entertainment. The union hall is now a private residence.

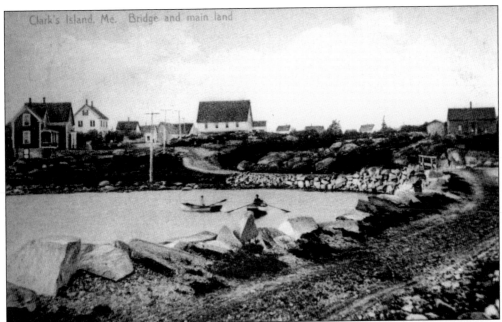

In this close-up photograph of the Clark Island Causeway, dories row around in the cove, possibly looking for herring. During nor'easters, the causeway would wash out. Large pieces of granite from the local quarry were used to shore up the causeway and protect it during ferocious Maine storms.

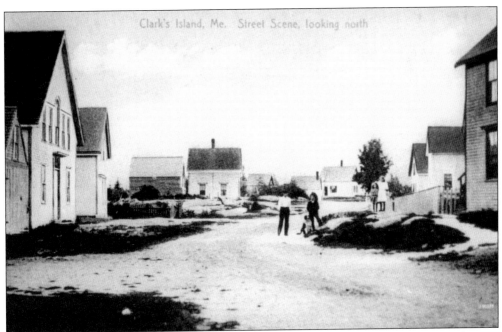

This Clark Island view looks down Main Street toward the water and the Craignair Inn. As seen in other village photographs, the street is dirty and only one tree is visible. Trees were cut down and used for heat, home building, and shipbuilding.

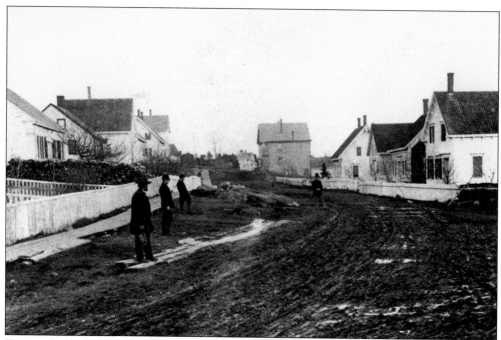

Tenants Harbor's Main Street, viewed from its lower end, still looks amazingly similar to this image, although the road has been paved and narrowed. The picket fence has disappeared.

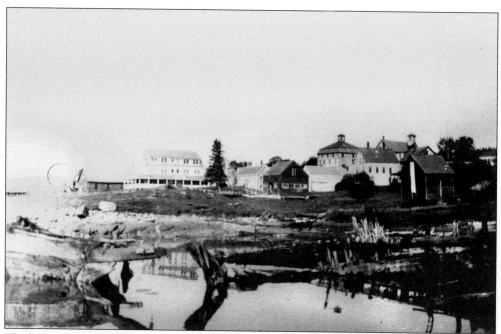

The large wooden building at center left is the old Wan E Set Inn, now remodeled and prospering as the East Wind Inn, on Tenants Harbor. Although it has been updated to keep pace with modern needs and regulations, the East Wind retains the old-fashioned feel of a traditional seaside vacation spot.

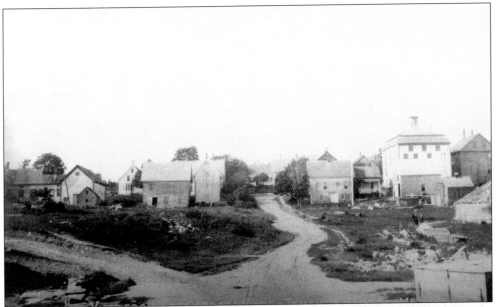

Tenants Harbor is seen from the Steamboat Wharf in the early 1900s. The building at far right (partly out of view) housed the horse-operated windlass for hauling vessels up the shipways.

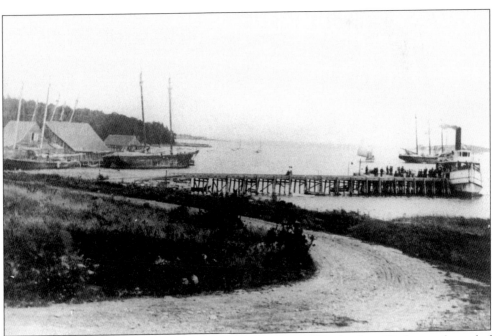

The Steamboat Wharf in Tenants Harbor is now used as a public landing. Tied up at the end of the wharf and loading passengers is the steamer *Mineola*, launched in Port Clyde in 1901.

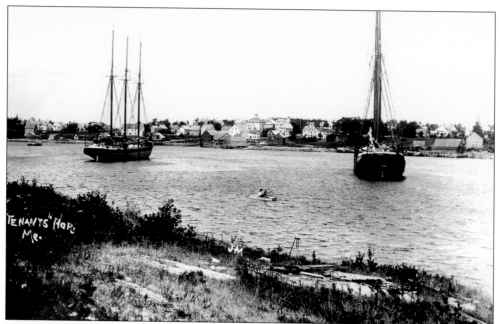

This photograph was taken in 1908 at Tenants Harbor. Shown to the left is the 302-ton three-masted schooner M. K. *Rawley*, built by the Bean and Long Company of St. George in 1874. To the right is the schooner *Alice Murphy*.

The 1950s-vintage Cadillac ambulance is parked in the original fire station at Tenants Harbor on November 1, 1959. Considered state-of-the-art at the time, the ambulance now would never pass state and federal regulations. Pictured behind the wheel is William Brown of South Thomaston. (Courtesy of the *Courier Gazette*.)

These early 1930s photographs were taken from the Barter home and depict before and after the baseball field was built, changed, and developed. Barter's Garage can be seen at the bottom of the hill. The Dodge-Hall farm is across the street. In the background is Tenants Harbor.

Here, the Dodge-Hall farm has been torn down and the bleachers were built in its place.

Known as the "Village Hermit" of Tenants Harbor, eccentric Arthur Pierson lived in a truck cargo box in the woods behind the St. George School. Around 1963, townspeople built a one-room cabin for Pierson, but he refused to use it because he was barred from filling it with all his oddities. In the photograph below, you can see some of the many items Pierson collected and brought back to "his home." He is still remembered by many natives in St. George. (Courtesy of Tom Damery.)

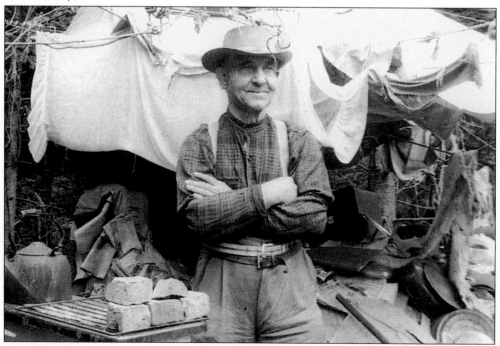

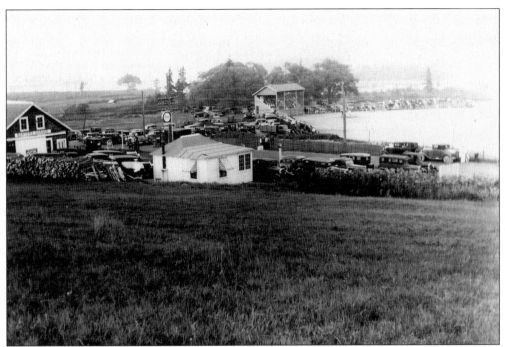

In the above view of the baseball field, the Dodge-Hall farm has been razed and new grandstands built, with the field rotated 30 degrees. Meanwhile, Ruth's Luncheon has also been rotated and a wing added. In the later view below, another wing has been added to Ruth's and the cars at the field are a later vintage.

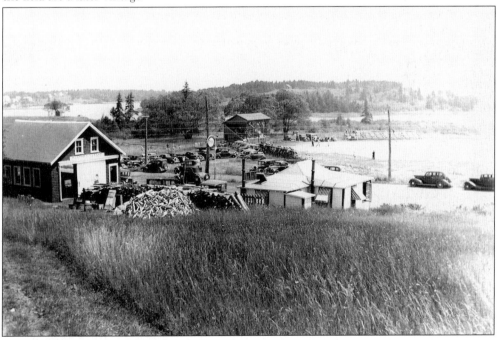

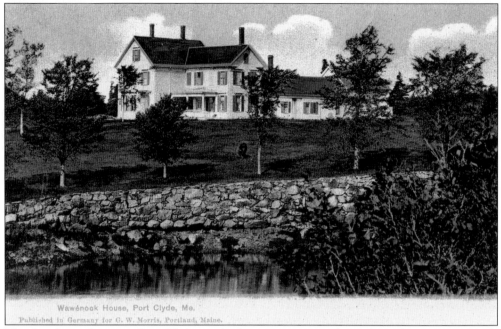

This handsome home in Port Clyde was built as a private residence for a ship-owning family named Washburn. Later, it was owned by Capt. James and Caroline (Hupper) Balano, who spent their honeymoon here. Eventually, the Balanos moved to the center of Port Clyde and the structure became a summer hotel before being torn down.

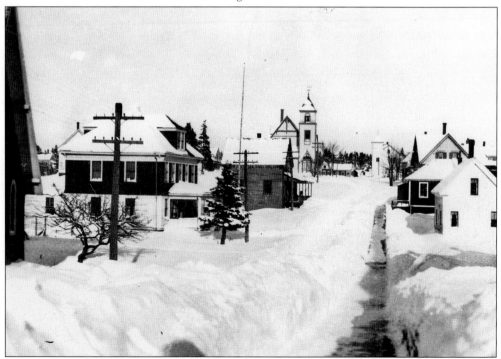

Several feet of snow could shut down the roads in Port Clyde, but shoveled paths provided the necessary access to the working waterfront. This photograph dates from the early 1900s.

This Cape-style house on Horse Point Road in Port Clyde, once the home of the Norris Seavey family, was purchased by artist N. C. Wyeth in the 1920s and became the subject of his famous painting *Bright and Fair—Eight Bells*. The Wyeth family still owns the house, overlooking Muscongus Bay, and several generations of Wyeths continue to spend summers in and around St. George.

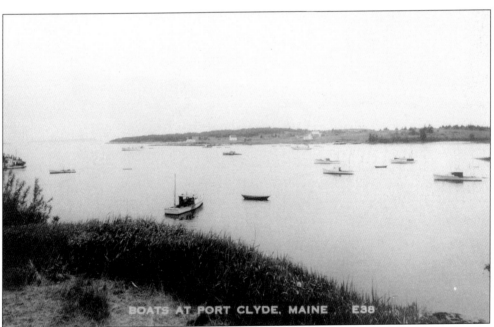

In this early 1930s photograph, Port Clyde Harbor has only a handful of work boats; today, the harbor is chockablock with lobster boats, draggers, and pleasure craft. Also based in the harbor is the passenger ferry to Monhegan Island, operating all year from its own dock.

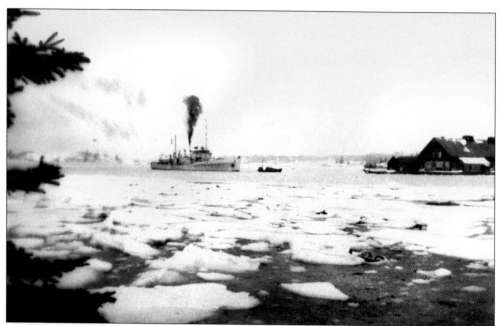

On February 13, 1934, the *Harriet Lane* was called in to break up the ice clogging Port Clyde Harbor. Even in winter, local fishing vessels needed to get out to open water. (Courtesy of Mrs. R. B. Ulmer.)

The life-size metal sculpture *St. George and the Dragon*, created by Robert "Dan" Daniels, was placed on the lawn of the St. George Town Office in 1998. It is a symbol of the town's past and now the present. The sculpture has also become an attraction to tourists driving through town. (Courtesy of Abby Hickey.)

Mary Elinor Jackson was so highly regarded for her generosity in lending books to friends and neighbors, among other kind acts, that after she and her brothers died, members of the community moved her home to Main Street and opened a library there in 1935. Miss Jackson, the Boston-educated daughter of a wealthy sea captain, suffered from crippling joint disease and the loss of her family's fortune following the decline of sailing vessels with the development of railroads and steamships. Born in 1855, she is remembered for retaining her grace and cheerfulness despite many hardships.

ACKNOWLEDGMENTS

This book was a project inspired by the St. George bicentennial in 2003. It came together as a result of curiosity and determination. I would like to thank Jim Skoglund for writing the introduction. A special acknowledgment goes to the Marshall Point Lighthouse Museum, especially Dana Smith, for access to its photograph collection. Most of the photographs in this book came from albums located at the museum. Thanks to Arcadia Publishing for its patience; Kathleen Brandes, Margaret Neeson, and Deborah DuBrule for their help with writing the captions; and Bill and Abby Hickey for allowing the use of their photograph and postcard collection and for scanning images. Many other St. George residents were generous in sharing their knowledge and lifelong memories of the villages. Thank you to all.

I hope everyone who looks through this book learns some new facts about St. George or sees photographs that evoke smiles and memories. For more information about St. George and its villages, visit the Marshall Point Lighthouse Museum in Port Clyde, a village of St. George, Maine. The museum, which has many fascinating historical displays and more than 60 photograph albums, is open from May through October..